IMAGES
of America

THE OVERLOOK OF CLEVELAND AND CLEVELAND HEIGHTS

IMAGES
of America

THE OVERLOOK OF CLEVELAND AND CLEVELAND HEIGHTS

Marian J. Morton

ARCADIA
PUBLISHING

Copyright © 2010 by Marian J. Morton
ISBN 978-0-7385-7822-4

Published by Arcadia Publishing
Charleston, South Carolina

Printed in the United States of America

Library of Congress Control Number: 2009912156

For all general information contact Arcadia Publishing at:
Telephone 843-853-2070
Fax 843-853-0044
E-mail sales@arcadiapublishing.com
For customer service and orders:
Toll-Free 1-888-313-2665

Visit us on the Internet at www.arcadiapublishing.com

This book is dedicated to my grandchildren, Grace Allison Morton, Ashwin Dasgupta, Jatin Dasgupta, and James W. Garrett IV, whose photographs grace this book.

CONTENTS

Acknowledgments

First and foremost, thanks to Kara Hamley O'Donnell, whose generosity and expertise have, as always, made this book possible. Thanks also to Bill Barrow, who lent me some of his personal Overlook photographs; to Charles Miller, Doty and Miller Architects; Chris Krosel, Cleveland Catholic Diocese; Katie Stricker, Ursuline College Archives; Beth Lucas, Cerebral Palsy Foundation; Cyndy Bernheimer, Jean Breitzmann, and Janet Kopp, Overlook House; Marcia Hudgel and Chris Riker, Nottingham Spirk and Design; Jill Tatum and Helen Congress, Case Western Reserve University Archives; and Jill Jefferis, College Club of Cleveland. Special thanks to Anne Sindelar of the Western Reserve Historical Society, who found the cover photograph for me, to Patricia H. Beall for allowing me to use the photographs of the Patrick Calhoun mansion, and to Hope Hungerford for finding the photograph of the Homer H. Johnson home for me.

INTRODUCTION

The splendid view of Cleveland and Lake Erie from the Garfield Monument in Lake View Cemetery—the final resting place of the assassinated president—inspired Patrick Calhoun's ambitious Euclid Heights allotment in 1890. Or so the story goes. At any rate, a stone's throw from the monument, Calhoun, a railroad lawyer-turned-real estate speculator, laid out the Overlook, a curving promenade along the bluff that overlooked the lake, the city, and two small colleges. Calhoun intended this premier residential boulevard to attract affluent Clevelanders to Euclid Heights. Within two decades, the Overlook was lined with the great mansions and elegant gardens that gave the new suburb of Cleveland Heights its identity as an "aristocratic little village," to quote the *Cleveland Plain Dealer*. Even more quickly, however, Calhoun lost his fortune and the Overlook, its cachet. Both the rise and the decline of the Overlook were a product of Calhoun's large ambitions and even larger forces that transformed the city and the suburb: prosperity and depression, peace and war, streetcars and automobiles, Clevelanders' changing tastes and aspirations.

The Overlook was modeled after the grand residential avenues of the 19th century, such as Chicago's Prairie Avenue, Detroit's Woodward Avenue, Buffalo's Delaware Avenue, and, of course, Cleveland's Euclid Avenue. These were created by the confluence of great wealth with the Romantic admiration for the natural landscape, especially when human beings had improved it. Set back from broad boulevards, stood stately mansions surrounded by vast lawns, intended to impress passersby. Social critic Thorstein Veblen described this as "conspicuous consumption"; most avenue residents would have happily agreed. Their magnificent estates represented their considerable personal and professional success. Why be modest?

Along Euclid Avenue lived many of Cleveland's wealthy industrialists, merchants, and professionals. Most made their fortunes as Cleveland made the transition from a small commercial village of native-born Americans to a booming industrial metropolis with a population drawn from all over Europe. Clevelanders called the 200 homes on 4 miles of Euclid Avenue "Millionaires' Row."

When Calhoun unashamedly borrowed the avenue's name for his Euclid Heights allotment, he expressed not only his own exuberant hopes, but those of the prospering city whose mills and refineries were going full blast, whose population was burgeoning, and whose boundaries were expanding west and east. Thanks to the streetcar, Cleveland families had already begun to move east up Euclid Avenue into the early suburban communities of Glenville, Collinwood, and Collamer. Calhoun hoped that the southeast corner of East Cleveland Township would be their next destination.

That corner, then a sparsely settled country village, became Cleveland Heights in 1901. Calhoun was not the suburb's first developer, only its most ambitious. The allotment's generous boundaries were Mayfield Road on the north, Coventry Road on the east, Cedar Road on the south, and the high bluff on the west. He bought most of the property from Dr. Worthy Streator, who lived on Euclid Avenue but operated a farm at the top of the hill.

Calhoun intended the Overlook and Euclid Heights to be "the chosen resort of the wealthiest Clevelanders," according to the July 3, 1892, *Cleveland Leader*. In 1896, he donated to the City of Cleveland properties down Cedar Glen and along Euclid Avenue and built a streetcar line that tied his allotment to the city and to the park system that stretched from University Circle to the lakefront. Both his allotment and the new suburb of Cleveland Heights benefitted. In 1910, the Overlook's imposing mansions rivaled those on Euclid Avenue.

Soon after, Calhoun suffered serious financial reverses and survived a sensational trial for bribery in San Francisco. The unsold portions of the Euclid Heights allotment were purchased at sheriffs' auctions in 1914 and 1915 to satisfy his debts. Tastes in suburban living had changed since the 1890s. Homes built in the 1910s, while gracious and handsome, were less formal and smaller than the huge urban mansions on the Overlook. During the 1920s, the new residents of Cleveland Heights bought more fashionable homes on more fashionable streets. Cedar Glen became clogged with automobiles, and the Overlook, once on the cutting edge of suburban settlement, became a suburban backwater. Its founding families began to move out; the first institutions, Ursuline College and the First Church of Christ, Scientist, Cleveland, moved in.

The Depression devastated Cleveland's heavy industry economy, creating widespread unemployment and financial hardship that was felt even in middle class Cleveland Heights. During World War II, the region's economy recovered, but housing and infrastructure fell into neglect. The economic downturn and the war hastened the Overlook's decline; its huge homes became too expensive to maintain. In the postwar housing shortage, some of the Overlook's mansions became multifamily dwellings. Two large apartment buildings replaced three of the grandest mansions, and nonprofit and social service agencies moved rapidly into other homes. At the end of the 1950s, Case Institute of Technology (now Case Western Reserve University) moved up the hill from University Circle and purchased and demolished some of the remaining mansions and the Ursuline College buildings on the Overlook and Carlton Road for residence halls and fraternity houses. The last of the first families had already left the boulevard.

The Overlook never became the suburban version of Euclid Avenue, but neither was it swallowed up by commerce and industry, as Millionaires' Row had been. Only three of the original mansions remain on the Overlook, but the stone walls that once bordered gardens and lawns are reminders of the boulevard's glory days. The carriage houses on Herrick Mews that once housed horses, cars, and servants are now listed on the National Register of Historic Places. The Overlook is visible for miles around because of the towering campanile of Nottingham Spirk and Design (the former First Church of Christ, Scientist, Cleveland), the symbol of the boulevard's present potential, like the new townhouses built just to the east of the Mews.

The view of the city and the lake from the Garfield Monument is as splendid today as it was in 1890. There are fewer smokestacks and factories to the west, signaling the decline of Cleveland as an industrial giant; the two small colleges at the foot of the bluff have become Case Western Reserve University and the dominant presence on the Overlook itself, representative of the city's growing service economy. In the last half century, both Cleveland and Cleveland Heights—like other industrial cities and inner-ring suburbs—have lost population, as the outward migration, initially encouraged by Calhoun himself, continued.

Calhoun early and magnificently saw the possibilities of transforming farmland on the heights above the city into an elite suburban neighborhood, although he reaped little financial benefit from his Euclid Heights allotment, nor did he live there long. Like other ambitious developers of the late 19th century, Calhoun literally and figuratively paved the way for future developments, and in its brief heyday, the Overlook added luster to the suburb that soon outstripped it. Calhoun, the visionary, could not have imagined the transformation of his elite residential boulevard over the last century, but Calhoun, the optimist, might have remained hopeful for its future.

One

TURN-OF-THE-CENTURY
CLEVELAND
1880–1900

Patrick Calhoun could see that Cleveland was destined for greatness. In 1890, its population of 261,353 made it the 10th biggest city in the country; in 1910, Cleveland had climbed to sixth place with a population of 560,663. The city's location on Lake Erie, between the iron ore deposits in the Mesabi Range to the west and the Pennsylvania coal mines to the south, helped make Cleveland an industrial giant. It became a leader in the making of iron and steel, ships, and later, automotive parts. A local boy, John D. Rockefeller, became the richest man in the world, thanks to his Standard Oil refineries. Cleveland became a transportation hub; on land, railroads supplanted the Ohio and Erie Canal; on the lake, steel ships replaced the old sailing vessels. Reflecting the robust economy, Euclid Avenue mansions multiplied.

Clevelanders were proud of their booming city and its grand downtown. Its handsome Public Square (then called Monumental Square) boasted the Soldiers and Sailors Monument, an imposing memorial to Clevelanders who had served in the Civil War. Just to the east of Public Square on Superior Avenue, wealthy Clevelanders, including Rockefeller, financed the Euclid Avenue Arcade. When Cleveland celebrated its centennial in 1896, organizers fashioned a mammoth celebratory (and temporary) arch on the square.

As mills and refineries spewed smoke and chemicals into the air and water, enriching their owners and employing thousands of men, women, and children, Clevelanders began to worry that the beauties of nature would be lost. Public parks would be the answer; generous donors made these possible—Jeptha Homer Wade, William J. Gordon, and John D. Rockefeller. Western Reserve College and Case School of Applied Science, persuaded by the city's evident promise and a $500,000 gift from industrialist Amasa Stone, had recently relocated to Euclid Avenue in University Circle.

No wonder Calhoun saw a glowing future for his allotment high on a bluff overlooking this thriving city.

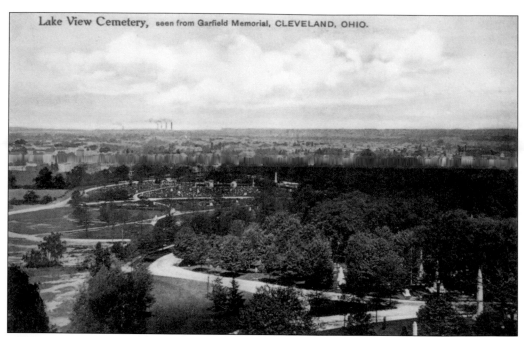

Lake View Cemetery, seen from Garfield Memorial, CLEVELAND, OHIO.

THE VIEW FROM THE GARFIELD MONUMENT. Patrick Calhoun could have seen in the distance Lake Erie (hence Lake View's name), the smokestacks of Cleveland's flourishing industries, dense woods, and the homes and shops of Clevelanders who were moving east of the city's boundaries. John D. Rockefeller himself had his residence nearby in East Cleveland Township. Reportedly inspired by the sight, Calhoun quickly began to acquire the properties for Euclid Heights. (Cleveland State University Special Collections.)

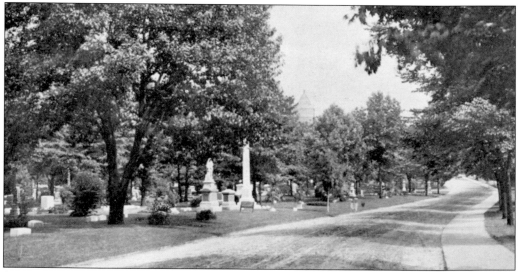

LAKE VIEW CEMETERY LANDSCAPE. Advertisements for Euclid Heights often referred to the attractions of Lake View. Calhoun correctly anticipated that wealthy families whose stately headstones and classical statuary already graced the cemetery would make their temporal homes nearby in Euclid Heights. The cemetery's landscape designers laid out curving roadways, lined with imposing monuments. Calhoun hired one of those designers, E. W. Bowditch, to create the curving, picturesque streets of Euclid Heights. (*Picturesque Cleveland*.)

MOSES CLEAVELAND STATUE. Cleaveland, lead surveyor for the Connecticut Land Company, arrived at the banks of the Cuyahoga River in July 1796. He stayed only long enough for his surveyors to lay out the village and then returned to Connecticut. Clevelanders honored him by naming the village after him, after shortening his name, and by placing this statue, designed by James G. Hamilton, on Public Square in 1888. (*Picturesque Cleveland.*)

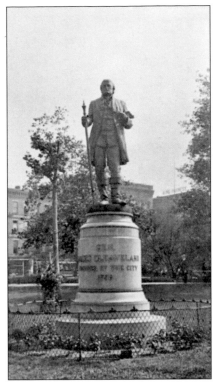

THE MOUTH OF THE CUYAHOGA RIVER. Cleaveland chose the site where Lake Erie met the Cuyahoga River, because it seemed well suited for the commercial center that he had in mind. The river has remained key to the city's economic well-being as a port for raw materials and manufactured goods and more recently, as a venue for recreation and tourism. (*Picturesque Cleveland.*)

IRON ORE DISTRICT. The city's location on Lake Erie, east of iron ore deposits and north of coal mines, was perfect for the manufacture of iron and steel products, which could then be transported across the country by one of the city's several railroads. Cleveland emerged as an industrial power in the years after the Civil War; by 1900, Cuyahoga County ranked fifth in the nation in the production of iron and steel. *(Picturesque Cleveland.)*

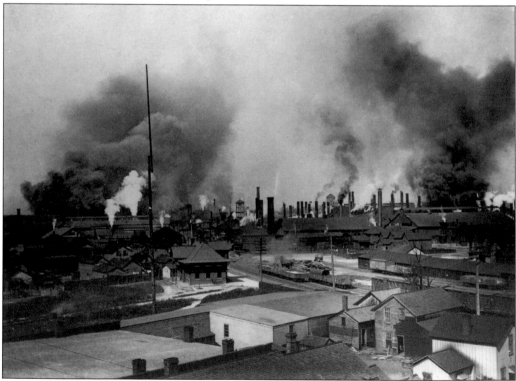

CLEVELAND ROLLING MILLS, C. 1890. These mills, founded on Cleveland's south side by Henry Chisolm, represented the city's industrial potential. Specializing in iron and steel parts, the factory employed hundreds of workers; many were recent European immigrants. Its smokestacks polluted the air, persuading many of Cleveland's wealthy families to move as far from them as possible. Advertisements for suburban allotments, like Euclid Heights, often boasted of their "pure, exhilarating, and healthful" air. (Western Reserve Historical Society.)

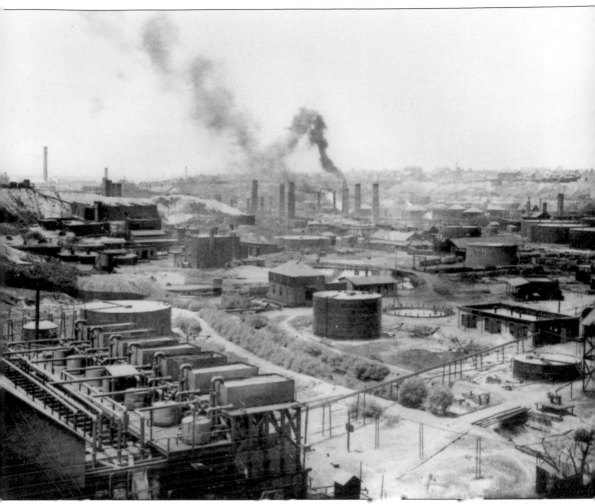

STANDARD OIL OF OHIO REFINERIES, 1889, His refineries—and his eventual monopoly of oil refining- made John D. Rockefeller the richest man in the world. Rockefeller probably lent Calhoun money to develop Euclid Heights through the Cleveland Trust bank, and he allowed his name to be used in Calhoun's advertisements for the allotment, probably in hopes of recouping his investment. (He probably didn't.) Rockefeller invested in real estate as well as oil and owned hundreds of acres in what would become Cleveland Heights and East Cleveland. In 1938, he gave to those two suburbs Forest Hill Park, where his own estate had been, and his son, John D. Rockefeller Jr., initiated the innovative Forest Hill allotment on the northeast section of the estate in the late 1920s. (Western Reserve Historical Society.)

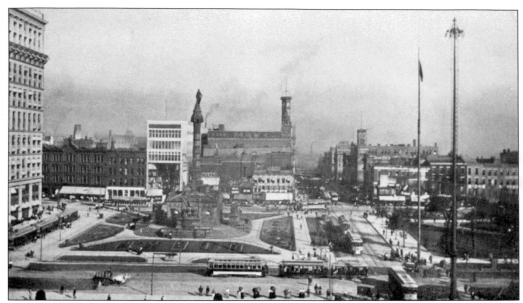

PUBLIC SQUARE (MONUMENTAL SQUARE). Levi Scofield's Soldiers and Sailors Monument, completed in 1894, appears in the left foreground of this photograph. To the right is a wooded quadrant of the Public Square that retained some of the characteristics of the New England village that Cleveland's surveyors had intended to re-create. The square had already become the terminus for streetcars, the center of this bustling city on the move. (*Picturesque Cleveland.*)

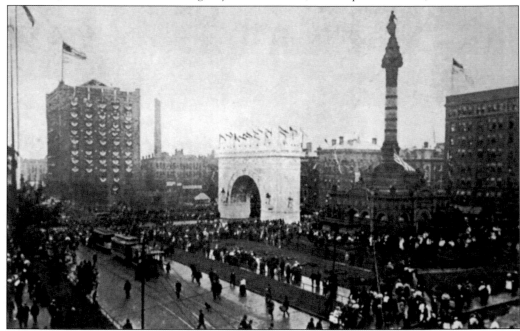

PUBLIC SQUARE, 1896. Cleveland celebrated its centennial in grand style, with speeches, parades, and an imposing, but temporary, arch constructed on Public Square. Flags flew from flagpoles and windows, and crowds gathered on the square to cheer the city's glorious past and present and to anticipate a prosperous future. The Soldiers and Sailors Monument appears on the right. (Case Western Reserve University Special Collections.)

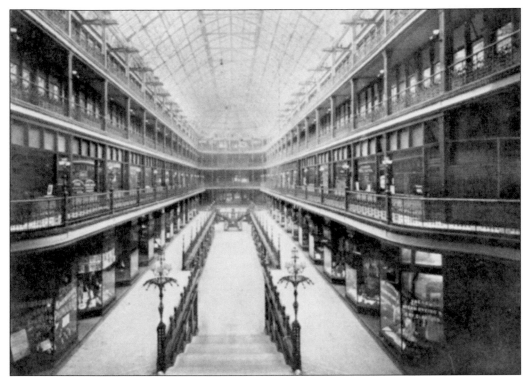

THE EUCLID ARCADE. Opened on Memorial Day, 1890, the Arcade, a glittering symbol of Cleveland's prosperity, linked Euclid and Superior Avenues. The interior boasted a three-story, glass-roofed court of shops and offices with railed balconies and wide stairways that connected the levels. Architect George Horatio Smith designed an imposing Romanesque-style entrance for the Superior Avenue entrance. Clevelanders called it a "crystal palace" and the first indoor shopping mall in the United States. (*Picturesque Cleveland*.)

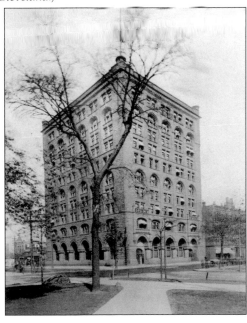

SOCIETY FOR SAVINGS. Also completed in 1890, this handsome red sandstone structure on Public Square was designed by the well-known Chicago firm of Burnham and Root. The arcaded entrances resembled the Superior Avenue entrance to the Euclid Arcade, just to the east. Myron T. Herrick, one of the bank's officers, was a major lender to Calhoun and became an early resident of the Overlook. (Cleveland Public Library.)

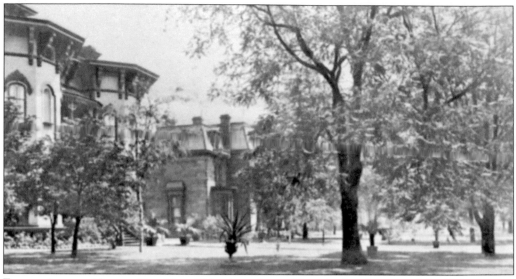

EUCLID AVENUE HOMES. Considered "the showplace of America" at the turn of the 19th century, Euclid Avenue would become a model for the Overlook. The avenue's stately homes were designed in a variety of styles, most by the city's best-known architects. The avenue was another tangible evidence of the city's wealth and promise, and Clevelanders were proud of this grand avenue even if they didn't live there themselves. (*Picturesque Cleveland.*)

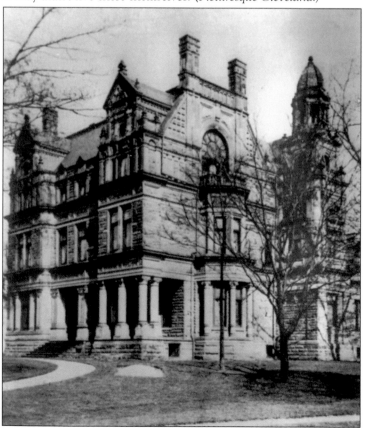

BRUSH MANSION. Charles Frances Brush invented the arc light, first demonstrated in Cleveland's Public Square in 1879. This invention, and others, made him famous and wealthy enough to build this massive Romanesque home at 3725 Euclid Avenue in 1887–1888. The architect was George Horatio Smith. Brush also hired Smith to design the Euclid Arcade. (Cleveland State University Special Collections.)

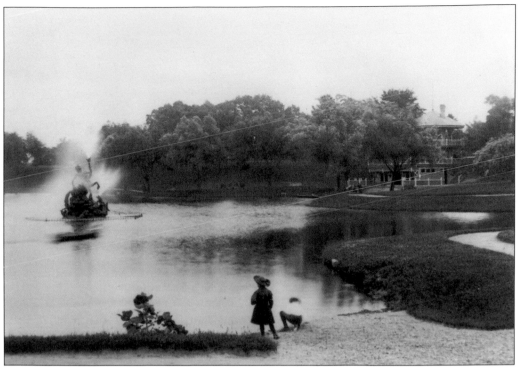

WADE PARK LAGOON, 1888. In 1882, Jeptha Homer Wade, inventor and philanthropist, gave the city its first significant gift of parkland, 64 acres along Euclid Avenue. This lagoon became a popular recreation spot. In the distance is the first Cleveland zoo, to which Wade donated animals. Wade also stipulated that a portion of the park be set aside for an art museum, now the home of the Cleveland Museum of Art. (Western Reserve Historical Society.)

GORDON PARK. William J. Gordon, a wholesale grocer and industrialist, bequeathed his 122-acre estate on the lake to the city when he died in 1892. The park, already landscaped, became a recreation facility with boating and swimming facilities. The Memorial Shoreway later cut through the park, leaving the lakefront portion as a fishing and boating spot. This photograph of the unspoiled park appeared in *Beautiful Homes of Cleveland* (1917). (Case Western Reserve University Special Collections.)

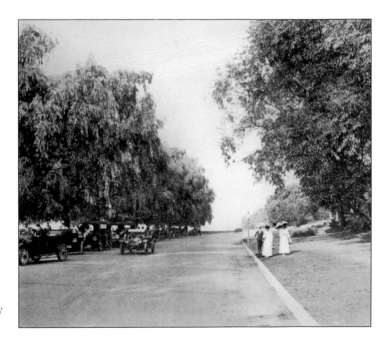

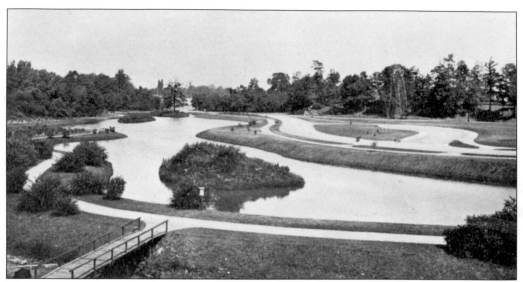

ROCKEFELLER PARK. To celebrate Cleveland's centennial in 1896, Rockefeller donated land to the city along Doan Brook that tied Wade Park to Gordon's lakefront park. West of East 105th Street, Rockefeller Lagoon provided facilities for swimming and ice-skating. The park is home to Cleveland's Cultural Gardens that honor the city's many ethnic groups and the Rockefeller Park Greenhouse. The boulevard is now named for Martin Luther King Jr. (*Picturesque Cleveland*.)

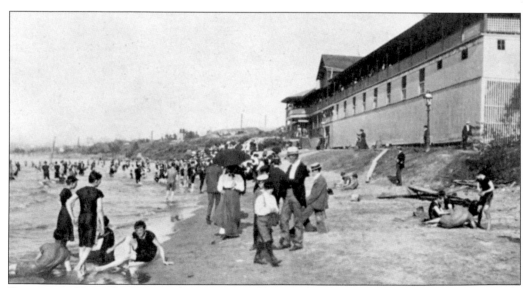

EDGEWATER PARK. In 1894, perhaps prompted by Gordon's gift of an east side lakefront park, Cleveland bought the property for Edgewater Park from industrialist Jacob B. Perkins. The park was located at West Fifty-eighth Street, now at the western end of the Memorial Shoreway. Edgewater Park became one of Cleveland's few public parks with access to the lake. This 1904 photograph testifies to its popularity as a bathing beach. (*Picturesque Cleveland*.)

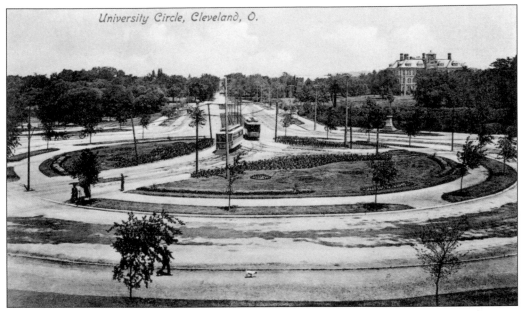

UNIVERSITY CIRCLE. The streetcar turnaround at Euclid Avenue and East 107th Street became University Circle when Western Reserve College and Case Institute of Applied Science moved nearby on Euclid Avenue. Case buildings are seen in this dawn-of-the-20th-century postcard. A dozen other cultural institutions would join the two academic institutions on the circle, but they would continue to dominate the neighborhood. (Cleveland State University Special Collections.)

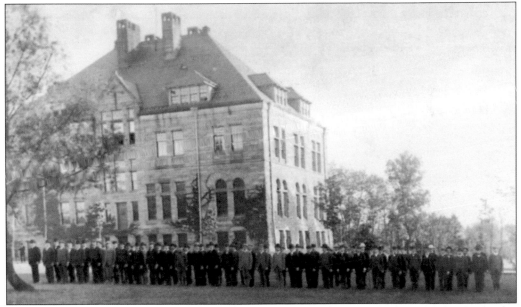

CASE SCHOOL OF APPLIED SCIENCE STUDENTS. Stone's gift required that Case School of Applied Science, founded in 1880 by Leonard Case, move from downtown Cleveland to Euclid Avenue, adjoining Western Reserve College. The move was completed in 1885. In 1898, these Case students formed a cadet corps in case they were called upon to serve in the Spanish-American War. They are lined up in front of the Case Chemical Laboratory. (Case Western Reserve University Archives.)

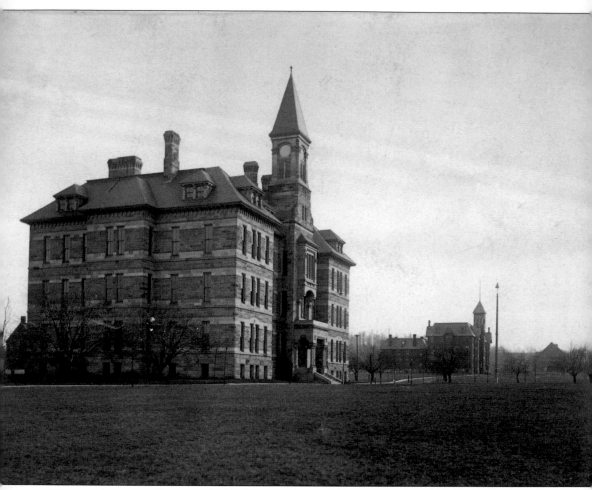

WESTERN RESERVE COLLEGE, 1888. Western Reserve College was founded in 1826 in the village of Hudson, Ohio, with moral support from the Congregational Church and financial support from the village and from community leader David Hudson, after whom the village was named. Despite financial difficulties, the college could boast a growing student body and an able faculty. In 1882, the college moved to Cleveland, where it had financial backers and students, to Euclid Avenue, on land donated by Amasa Stone. Its undergraduate college was named after Stone's son, Adelbert. Pictured here are, from left to right, Adelbert Main, Cutler and Pierce Halls, and the Adelbert Gym. Western Reserve Academy remained in Hudson. After decades of being neighbors and partners, Western Reserve College and Case School of Applied Science federated to become Case Western Reserve University in 1967. Adelbert Main was severely damaged by fire in 1991, but it has been entirely renovated and its historic character preserved. (Case Western Reserve University Archives.)

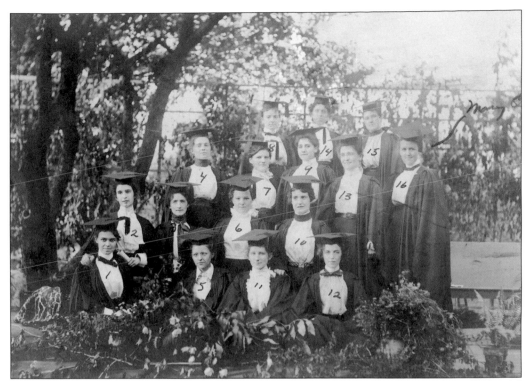

COLLEGE FOR WOMEN GRADUATES. In 1888, Western Reserve College trustees, reportedly fearful that women students were responsible for the institution's dwindling enrollment of men, voted to no longer admit women but authorized a separate facility, the College for Women, which graduated these proud women a decade later. The college would become Flora Stone Mather College in 1931. The numbers identify the graduates in the full photograph. (Case Western Reserve University Archives.)

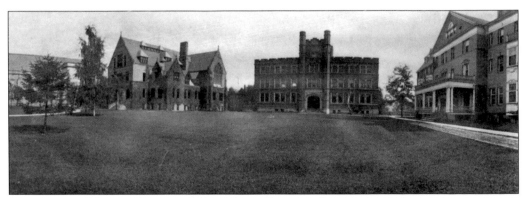

COLLEGE FOR WOMEN CAMPUS, 1900. The college was frequently the beneficiary of Amasa Stone's family, most notably his daughter Flora Stone Mather, who gave not only money, but energy and devotion and for whom the college was named. The Adelbert College faculty taught the women students without pay for the first three years of the college's existence. From left to right are Harkness Chapel, Clark Hall, Hayden Hall, and Guilford House. (Case Western Reserve University Archives.)

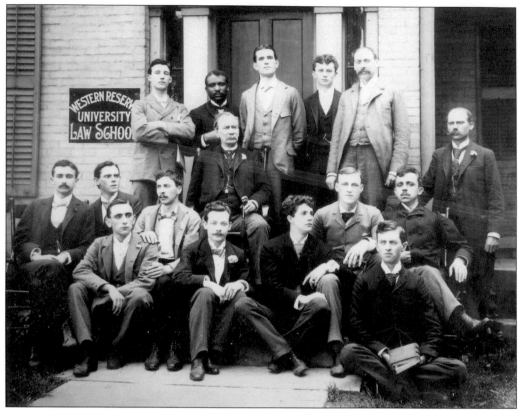

SCHOOL OF LAW CLASS OF 1895. The Western Reserve College School of Law opened in 1892 in a rented home at Adelbert Road and Euclid Avenue, where the College for Women had first met, with a first class of 24 students. Tuition was $100 a year. The school of medicine, which had was founded in 1843, and the school of law made Western Reserve College a university. (Case Western Reserve University Archives.)

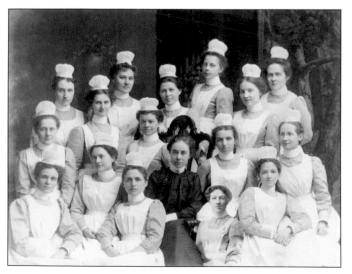

SCHOOL OF NURSING CLASS OF 1901. This is the first graduating class of the institution that began in 1898 as the Training School for Nurses of Lakeside Hospital, then located on Lakeside Avenue. In 1923, Frances Payne Bolton donated funds so that the school could move to University Circle, and the school, named after its benefactor, became an equal and independent school within the university. (Case Western Reserve University Archives.)

Two

FOUNDER AND FIRST FAMILIES
1890–1910

As Patrick Calhoun envisioned his real estate venture, he might well have taken the advice of Daniel Burnham, architect of the White City at the World's Columbian Exposition, which defined the public's idea of architectural splendor: "Make no little plans; they have no magic to stir men's souls . . . Make big plans, aim high in hope and work." Calhoun certainly thought big; his Euclid Heights was the largest, most ambitious allotment on Cleveland's east side.

Calhoun began purchasing properties in 1891. They were located in East Cleveland Township, except for a parcel at the southwestern corner of the allotment that was annexed by the City of Cleveland in summer 1892. Calhoun had purchased this parcel especially to create the curving boulevard on the bluff that became the Overlook. Calhoun reserved the first lots on this boulevard for prominent Cleveland industrialists, politicians, lawyers, and bankers. Many had political, professional, or family connections with each other. Calhoun hoped these families, and the exclusive Euclid Club he built for them, would attract other buyers. Due to a serious depression, the allotment got off to a slow start. By the end of the decade, however, Calhoun's street railway up Cedar Glen, and the return of prosperity, made Euclid Heights successful.

The suburb of Cleveland Heights was born shortly afterwards. Two Euclid Heights residents—J. W. G. Cowles and William Lowe Rice—were elected trustees of the hamlet in its first election in 1901, acknowledging the importance of the new suburb's most socially prominent neighborhood. In 1910, the Overlook was lined with huge mansions designed in the same styles by some of the same architects who created the mansions on Millionaires' Row—Alfred Hoyt Granger, Frank B. Meade, Abram Garfield, George Horatio Smith, and J. Milton Dyer. Calhoun's grand boulevard, and the streetcar he built on Cedar Glen Parkway, had encouraged the growth of both Euclid Heights and Cleveland Heights.

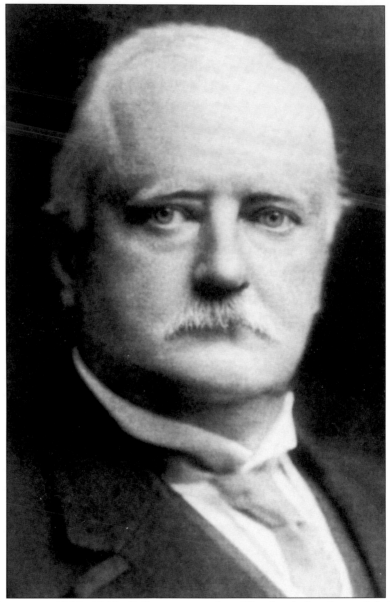

PATRICK CALHOUN, 1856–1943. Calhoun arrived in Cleveland already a celebrity. Born in South Carolina in 1856, he was the grandson of John C. Calhoun—once vice president of the United States, Democratic senator from South Carolina, and an early advocate for railroads. Heir to this political legacy, Calhoun trained as a lawyer who specialized in railroads, defending, buying, and consolidating them with his South Carolina law partners, Alex King and Jack Spalding. Clevelanders may have hoped that he would organize Cleveland's chaotic street railways. (Calhoun's fellow Democrat, Tom L. Johnson, tried.) Instead, Calhoun became engaged in his first and only real estate venture. His contemporaries described him as dynamic and energetic with great charm and energy, and the early success of Euclid Heights and the Overlook are evidence of his entrepreneurial abilities. Unfortunately, Calhoun left Cleveland to pursue other ventures in 1903, and when he finally returned, his allotment had fallen on hard times. (Cleveland State University Special Collections.)

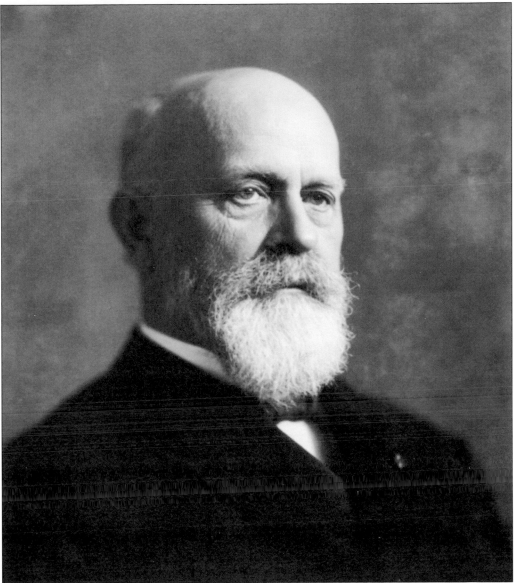

J. W. G. COWLES, 1836–1914. Cowles, one of the first elected trustees of Cleveland Heights, was also financial adviser to John D. Rockefeller and helped arrange Rockefeller's 1896 gift to the City of Cleveland and perhaps his loans to Calhoun. President of the Cleveland Chamber of Commerce, Cowles built two homes on what was then known as East Overlook in Euclid Heights. (Cleveland State University Special Collections.)

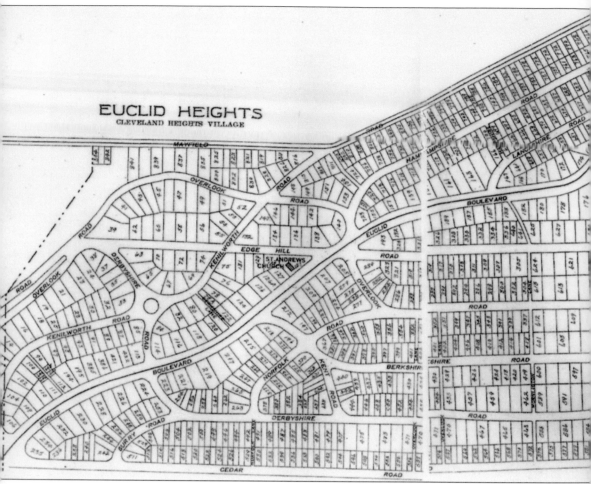

EUCLID HEIGHTS ALLOTMENT, 1903. The allotment was defined by the boundary line of the city of Cleveland to the west, Mayfield Road to the north, Coventry Road to the east, and Cedar Road to the south. The allotment ultimately contained 300 acres. Calhoun hired E. W. Bowditch to lay out the streets. Bowditch was already in Cleveland to help design its new park system and also do some redesigning of Lake View Cemetery. The cemetery's curvilinear pathways, intended to imitate nature and enchant the eye, are imitated on the western end of Euclid Heights. The dashed line that cuts through the Overlook represents the boundary of the city of Cleveland; next door neighbors on The Overlook might live in Cleveland or Cleveland Heights. (Cuyahoga County Archives.)

EUCLID HEIGHTS REALTY OFFICE. Calhoun's ads for Euclid Heights began to appear in July 1892 on the first page of the *Cleveland Plain Dealer's* Sunday real estate section. The site was described as Calhoun probably first saw it: a "park-like ridge, overlooking the most beautiful reach of Lake Erie . . . This is in the salubrious and beautiful region that has long been the chosen resort of the wealthiest Clevelanders," the ad continued, referring specifically to John D. Rockefeller, whose summer home was in East Cleveland Township near Lake View Cemetery. Later ads boasted that the allotment was "30 Minutes from Public Square by electric railway . . . We are in the City School District . . . The Air at Euclid Heights is Pure, Exhilarating, and Healthful. No Smoke or Dirt." Building restrictions were also spelled out and varied from street to street. Lots on the Overlook were not advertised, presumably reserved for especially prestigious purchasers and/or investors. Prospective buyers were directed to Cowles, John Hartness Brown, or this handsome office in its wooded setting on Kenilworth Road. (Cleveland State University Special Collections.)

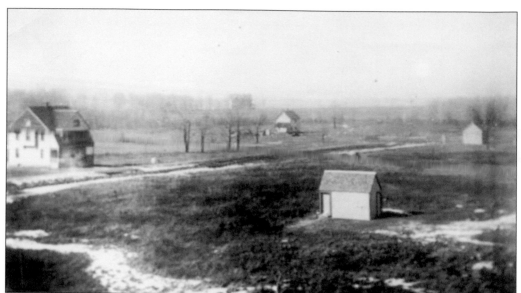

THE OVERLOOK, C. 1894. In the foreground are the few, modest homes on Bellfield Avenue in the Cedar Heights allotment, developed by Edmund Walton. In the far distance is the first mansion on the Overlook, built by architect Alfred Hoyt Granger for himself. Granger returned to Chicago in 1896, selling this home to Homer H. Johnson, who sold it two years later to his law partner Melvin B. Johnson. (City of Cleveland Heights.)

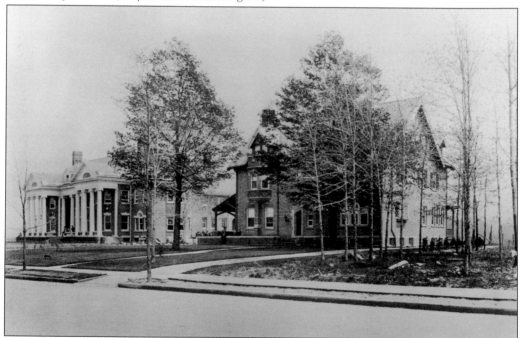

GRANGER/JOHNSON AND WILLIAM LOWE RICE MANSIONS. Granger designed these homes in two very different styles; compared to Rice's vast Colonial Revival mansion, Granger's own Tudor Revival home seems modest. These appear to be the only two homes on the Overlook when this photograph was taken. Rice named his home "Lowe Ridge"; the Johnson home was called "Uplands." (Western Reserve Historical Society.)

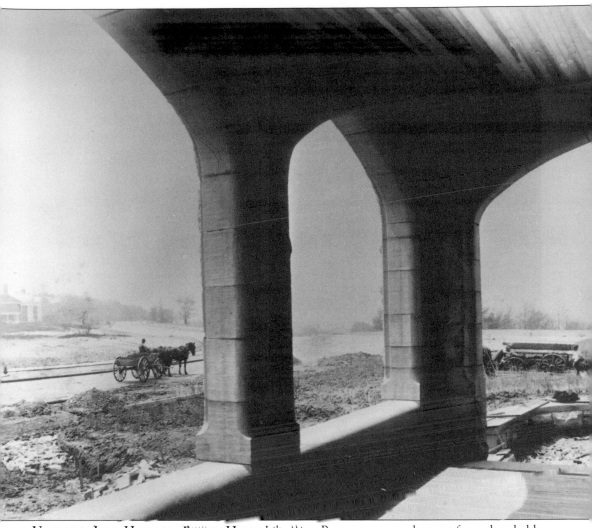

VIEW FROM JOHN HARTNESS BROWN HOME. Like Rice, Brown was an early agent for and probably a significant investor in Euclid Heights. Their homes may have been payment for their services. This view from the unfinished porch of Brown's home, completed in 1896, shows only the Rice and Granger homes in the distance on the east side of the street, and nothing at all on the west side. Home building in the allotment was slowed by the serious depression of 1893, and the streetcar had not yet made the Overlook easily accessible from downtown. It took a leap of faith—and probably some financial inducements—to build a home in what was still an isolated spot. (Western Reserve Historical Society.)

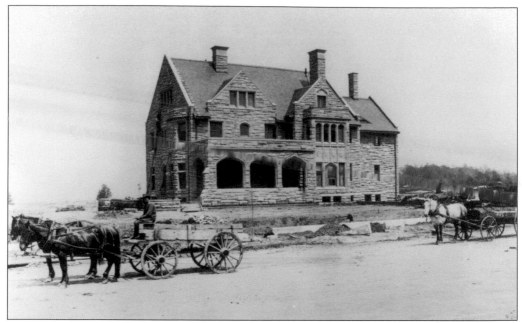

Brown Home under Construction. With the Rice and Granger homes, Brown's established the tone for the neighborhood as stately, perhaps ponderous. Frank Meade and Alfred Hoyt Granger designed Brown's home in the Richardsonian Romanesque style popular for grand homes and public structures, such as the nearby Garfield Monument and the Euclid Arcade. The mansion is listed on the National Register of Historic Places and is a Cleveland Heights landmark. (Western Reserve Historical Society.)

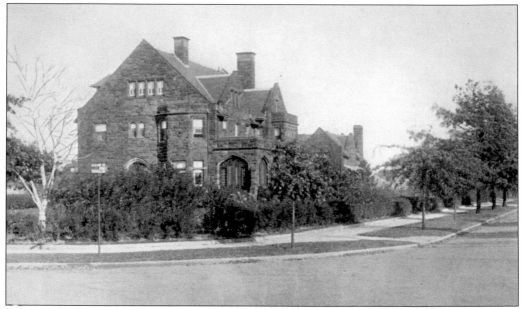

Brown Home, 2380 Overlook Road. The photograph shows the strategic location of Brown's home at Overlook and Edgehill Roads. In the near distance is the mansion's carriage house. Both buildings are still standing. Brown left Cleveland in 1913 after the murder of his neighbor Rice; the home was purchased by Walter D. Sayle. (Case Western Reserve University Special Collections.)

HOMER H. JOHNSON, 1862–1960.
Another early investor in the Overlook, Johnson shared his recollections of life on the Overlook with the Women's Civic Club of Cleveland Heights in 1929, describing Calhoun as "the big noise" and Rice and Brown as "the most influential men" in the development of the Heights. He recalled that his "interest in the Heights was kindled by my appreciation of the edge of the hill as a place of residence." (Western Reserve Historical Society.)

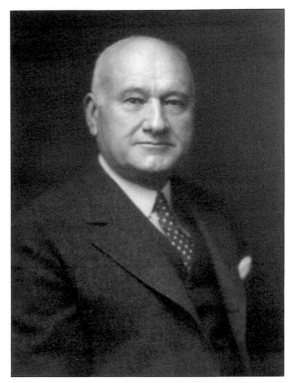

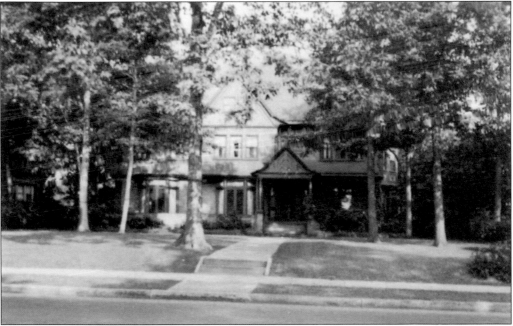

JOHNSON HOME, 2171 OVERLOOK ROAD. After selling the Granger home to his law partner, Johnson bought the home of A. S. Taylor at 2167 Overlook Road, just northeast of the Myron T. Herrick mansion. His son, modernist architect Philip Johnson, grew up in this traditional home. According to Philip Johnson's biographer, Franz Schulze, this Tudor home, which resembled the one Alfred Hoyt Granger built for himself, was remodeled by J. Milton Dyer. (Hope Hungerford.)

MELVIN B. JOHNSON, 1862–1920.
Johnson purchased 2141 Overlook from his partner Homer H. Johnson. Before moving to the Overlook, the law partners had lived next door to one another on Brookfield Road, now East Eighty-seventh Street, in the Hough neighborhood. The law firm of M. B. and H. H. Johnson had its office in the Society for Savings Building. A significant early client was the White Sewing Machine Company, which became White Motor Corporation. (Author's collection.)

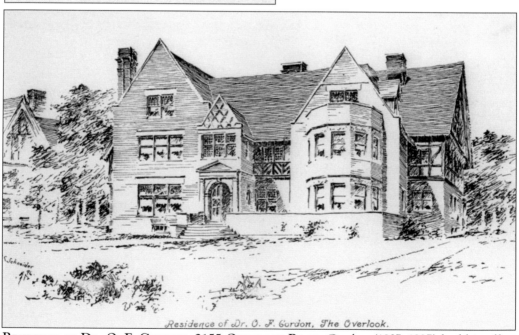

Residence of Dr. O. F. Gordon, The Overlook.

RESIDENCE OF DR. O. F. GORDON, 2155 OVERLOOK ROAD. Gordon (1837–1897) had his office on Euclid Avenue and his home on Prospect Avenue before he built this house on the Overlook. He probably died before he could occupy it. His widow sold the Tudor Revival home, next door to the Granger/Johnson house, to George N. Chandler in 1901. The home is attributed to Alfred Hoyt Granger and Frank Meade. (Cleveland State University Special Collections.)

HERMON A. KELLEY, 1859–1925. Kelley was a lawyer specializing in admiralty law and an active Republican. He was on the legal staff of the City of Cleveland in 1892 when Calhoun was drawing up the plans for Euclid Heights. His home, on the west side of the Overlook, was in the city. (Western Reserve Historical Society.)

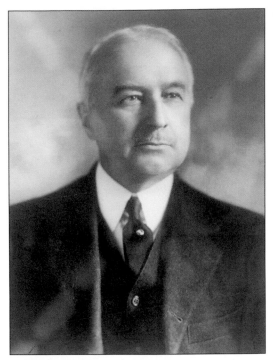

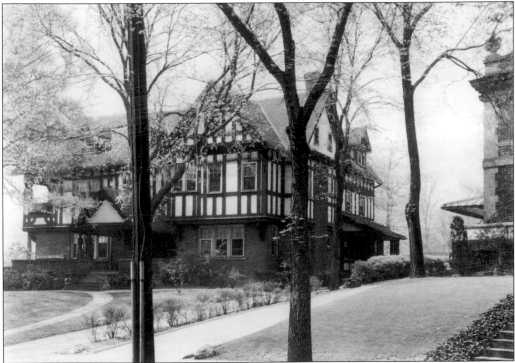

KELLEY MANSION, 2244 OVERLOOK ROAD. The imposing 20-room Tudor Revival home, completed in 1898, sat on the southwest corner of Overlook Road and Euclid Heights Boulevard and provided a prominent entrance to the Overlook. The home was sold to Ursuline College in 1926. (Ursuline College Archives.)

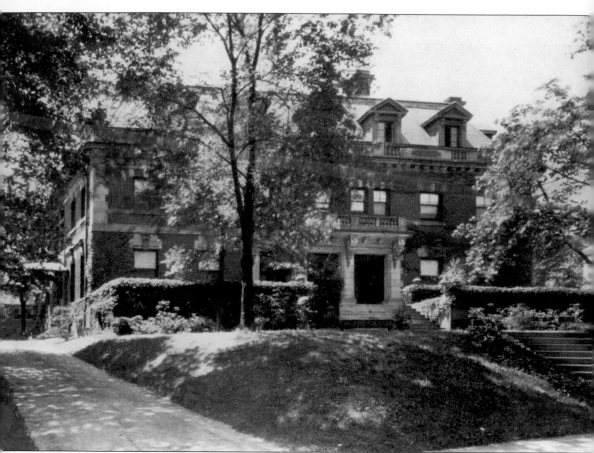

LOFTUS CUDDY MANSION, 2234 OVERLOOK ROAD. This dignified stone mansion, next door to Kelley's, was built for Loftus Cuddy (1852–1917), treasurer of the Lake Carrier Oil Company, who sold the home to A. S. Gilman. The architect was J. Milton Dyer, who also designed the Samuel Dodge home one door to the north on the Overlook, as well as Cleveland City Hall, and the home on Magnolia Drive that is now the Cleveland Music School Settlement. The Cuddy home was sold to Ursuline College in 1926 and became the college administration building. Its broad steps became an appropriate site for important college rituals. (See page 59.) (Ursuline College Archives.)

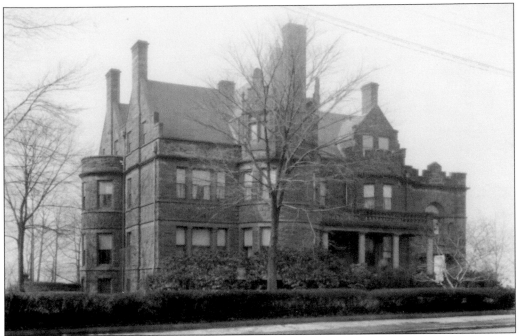

HOWELL HINDS MANSION, 2188 OVERLOOK ROAD. Hinds (1857–1926) was the president of the United Mines Corporation. This massive multi-chimney stone mansion was completed in 1898. Its architect, George Horatio Smith, also designed the Euclid Arcade and the Charles Brush home on Euclid Avenue. (See pages 15 and 16.) A Tiffany stained-glass window from the home was the family's gift to the Cleveland Museum of Art. (Nottingham Spirk and Design.)

HINDS REAR YARD. The back of the property sloped sharply down to Edgehill Road. Nellie E. Hinds remembered her garden, perhaps to the side of the home, with pride: "Our begonia garden was considered one of the finest in America." In 1928, Mrs. Hinds, then widowed, sold the property to the First Church of Christ, Scientist, and it is now the site of Nottingham Spirk and Design. (See pages 73 and 109.) (Nottingham Spirk and Design.)

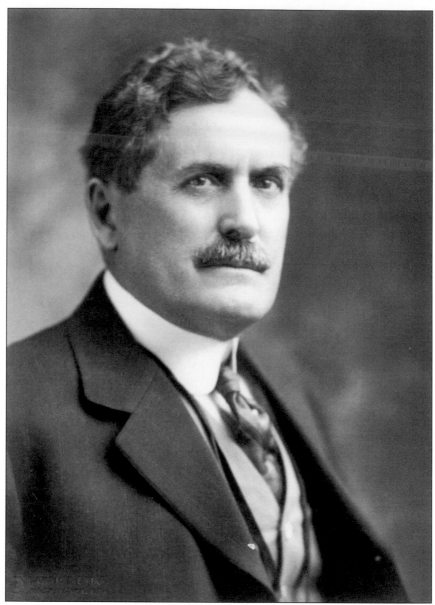

MYRON T. HERRICK, 1854–1929. The most famous of the Overlook's residents, Herrick was trained as a lawyer and joined the Society for Savings in 1886. In that capacity, he loaned Calhoun $60,000 for the purchase of the properties that became Euclid Heights. Before his move to the Overlook, Herrick served on the Cleveland City Council, 1885–1890. Because his Overlook home lay within the city of Cleveland, although it was on the east side of the street, the rumor—probably false—persists that Herrick had Cleveland's boundary lines drawn so that he would remain eligible to run for city office. Herrick was a Republican activist and governor of Ohio from 1903 to 1905. He counted William McKinley among his good friends, and on October 6, 1897, wrote to the president, "we are at last in our new home [on The Overlook], and are very much pleased with it . . . [I]t will never be completed as a home until you and Mrs. McKinley are under its roof." Herrick Mews, originally a continuation of Kenilworth Road, is named for him. (Western Reserve Historical Society.)

HERRICK MANSION, 2187 OVERLOOK ROAD. The sprawling Colonial Revival mansion was designed by Granger and Meade and completed in 1897. Its broad piazza and massive front door welcomed visitors like President McKinley. This detail also shows part of the gardens that extended south across Kenilworth Road (now Herrick Mews). The home became Overlook House, a Christian Science nursing facility. (See page 83.) (Western Reserve Historical Society.)

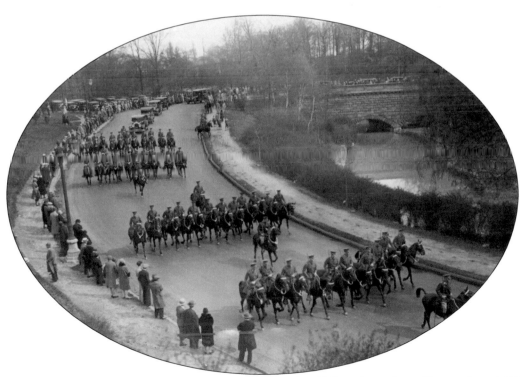

HERRICK FUNERAL PROCESSION, 1929. Herrick served as U.S. ambassador to France from 1912 to 1914 and was reappointed in 1921 by Pres. Warren Harding. Herrick was in Paris in 1927 to welcome Charles Lindbergh when he completed his solo flight across the Atlantic. Herrick died in Paris. His Cleveland funeral procession wound through Rockefeller Park on its way to Lake View Cemetery. (Western Reserve Historical Society.)

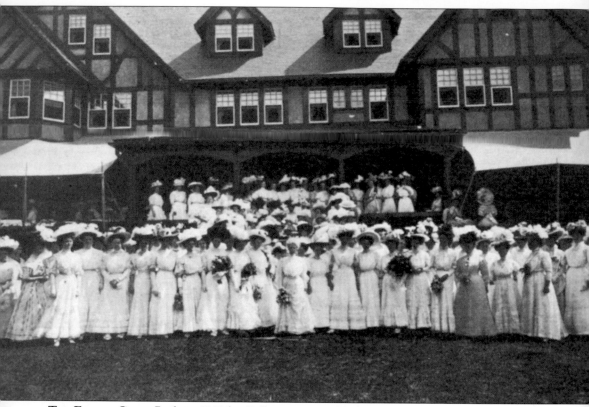

THE EUCLID CLUB. Built in 1901 by Calhoun as an added amenity for Euclid Heights residents, the club was often the scene of prominent social events, such as this one in 1908, the closing ceremonies of Miss Mittleberger's School. The school, founded in 1877, educated the daughters of Cleveland's socially prominent families, until it closed when its founder Augusta Mittleberger retired. This photograph of the school's graduating class and alumnae appeared in *Cleveland Town Topics*, which described the ceremonies as "impressing and very touching." The elegant Tudor-style club, boasting one of Cleveland's first golf courses, was also the site of a famous golf match between Herrick and Cleveland mayor Tom L. Johnson, who were both running for governor of Ohio. Herrick won both contests. The club was disbanded in 1912, and its golf course was developed as the Euclid Golf allotment. (Western Reserve Historical Society.)

SAMUEL D. DODGE, 1855–1941. Dodge was also a lawyer who had served in the U.S. district attorney's office. He specialized in real estate law and, like other Overlook neighbors, for some years acted as an agent for the Euclid Heights Realty Company. (Western Reserve Historical Society.)

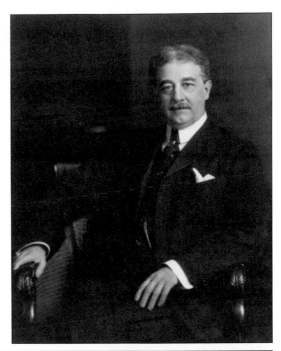

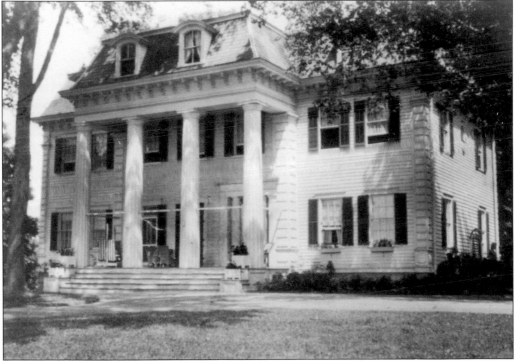

DODGE MANSION, 2224 OVERLOOK ROAD. Completed in 1902, this neoclassical revival home at the northwest corner of what is now Carlton Road and Overlook Road may have been designed by J. Milton Dyer. Dodge sold the home to Ralph Rex in 1920, and during the 1940s, it became doctors' offices. The home was demolished in the late 1960s by Case Western Reserve University. (Western Reserve Historical Society.)

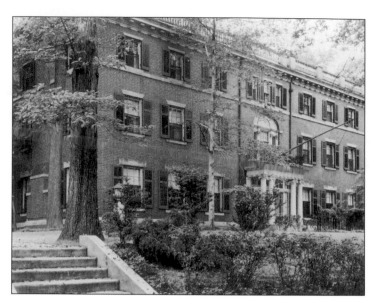

SHERWIN MANSION, 2214 OVERLOOK ROAD. Banker John Sherwin (1863–1934) was chairman of the board of Union Trust when he moved to the Overlook from 1560 Euclid Avenue. This handsome Georgian Revival home was designed by Meade and Garfield and completed in 1905. After Sherwin's death, it became a men's social club, and in 1944, Ursuline College bought it for a dormitory. (See page 78.) (Ursuline College Archives.)

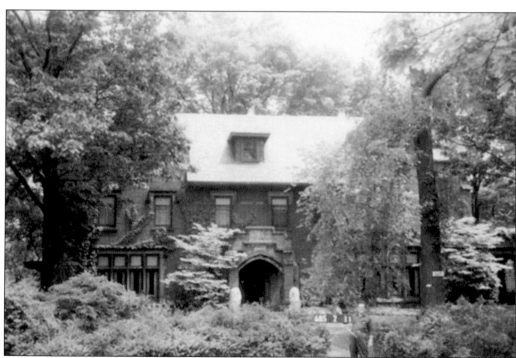

JOHN F. RUST JR. HOME, 2215 OVERLOOK ROAD. In 1904, Rust (1882–1938) purchased the site for this formal home, next door to the Eells mansion and three doors from his sister Gertrude Rust Chandler. In 1939, the home was purchased by Laurence H. and Robert C. Norton (see page 80), who brought from their Euclid Avenue home the stone lions that attend the front door in this photograph, taken in 1958 by Cuyahoga County. (Cuyahoga County Archives.)

W. D. B. Alexander, 1858–1929.
Alexander was president of the National
Screw and Manufacturing Company when
he built his home and carriage house on the
Overlook. In 1917, the home was sold to D.
Edward Dangler. (College Club of Cleveland.)

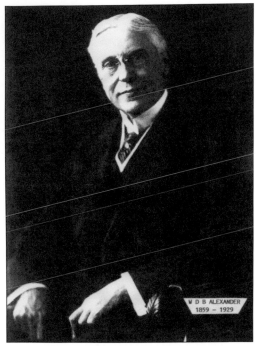

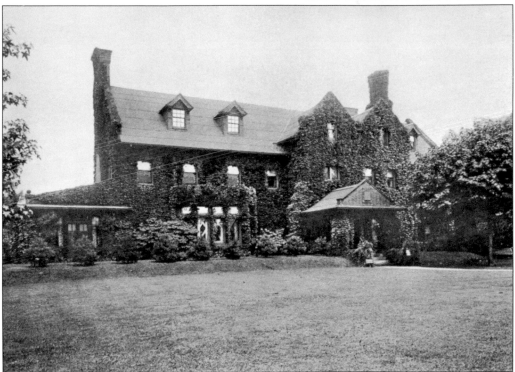

Alexander Mansion, 2348 Overlook Road. Designed by Franklin Meade and Abram Garfield,
the Tudor Revival home was completed in 1905. The mansion had 18 rooms and 5 bathrooms. It
was purchased by the College Club of Cleveland in 1951 and was designated a Cleveland Heights
landmark in 1978. (Case Western Reserve Special Collections.)

41

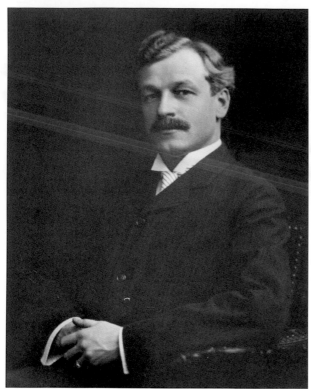

WILLIAM PENDLETON PALMER, 1861–1927. Palmer was president of the American Steel and Wire Company and a director of the Cleveland Trust bank when he built his home on the Overlook, next door to the Alexander mansion. (Western Reserve Historical Society.)

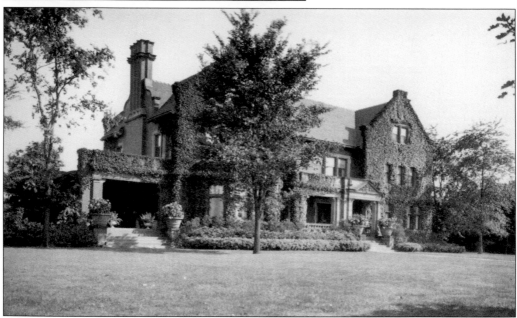

PALMER MANSION, 2332 OVERLOOK ROAD. Possibly designed by Meade and Garfield and completed in 1902, the mansion was demolished in the late 1930s. In 1914, *Cleveland Town Topics* waxed eloquent about the Palmers' gardens and lawns: "Upon the broad piazza one may look over the wide expanse of the city of Cleveland, lying at the foot of the [Edgehill] hill and to the lake beyond with no nearby house in sight." (Western Reserve Historical Society.)

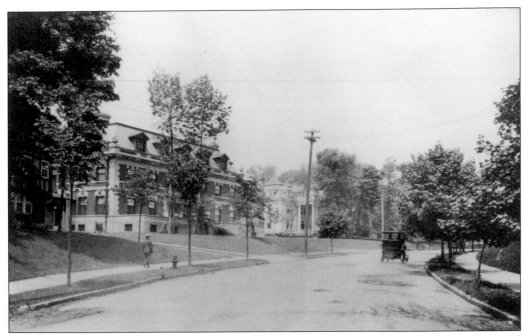

THE OVERLOOK, C. 1905. A panorama of the Overlook shows the Kelley, Cuddy, and Dodge—and in the far distance, Sherwin—homes on the left. Across the street to the right was the Herrick mansion. The curving street, like the trees Calhoun planted, was intended to enhance the picturesque quality of the grand avenue. (Western Reserve Historical Society.)

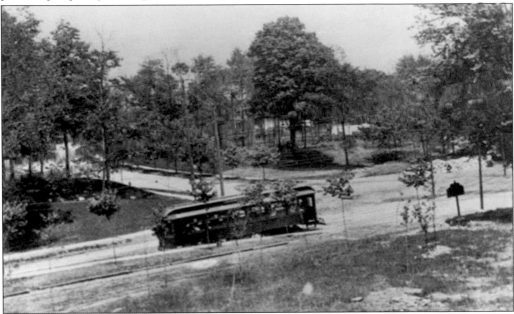

CEDAR GLEN PARKWAY, C. 1909. The streetcar that Calhoun built up Cedar Glen Parkway and Euclid Heights Boulevard was an enormous boon not only to his allotment, but also to the suburb. Streetcars also ran up Cedar Road and Fairmount Boulevard, and Cleveland Heights grew up around them. The Herrick mansion is almost visible in this photograph; the Eells mansion had not yet been built. (City of Cleveland Heights.)

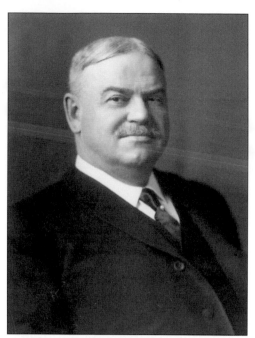

HOWARD P. EELLS, 1855–1919. Eells moved to the Overlook from Prospect Avenue. He was the organizer of the Bucyrus Steam Shovel Company, a director of several banks, and an important art collector. (Western Reserve Historical Society.)

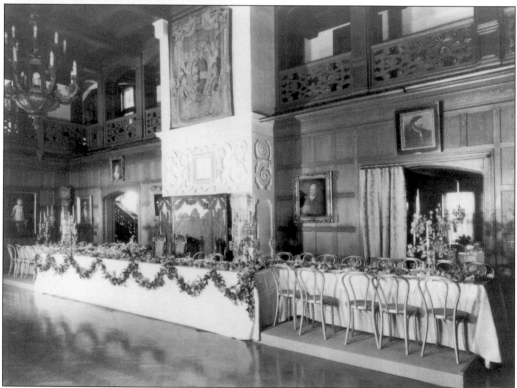

EELLS MANSION INTERIOR. The two-story great hall seen here was encircled by a carved wood minstrel's balcony. On the wall hung paintings from Eells' private collection. The enormous two-story fireplace was the room's focal point. When the Eells family had its first formal party in 1910, it was big news in the society pages of the local newspapers. (Western Reserve Historical Society.)

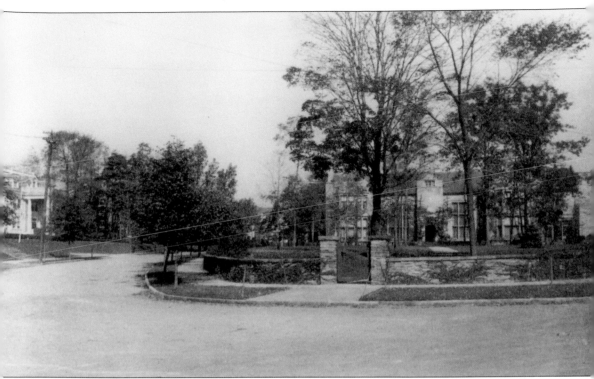

EELLS MANSION. The mansion designed by Meade and Hamilton in the manner of an English country estate was so prominently sited at Euclid Heights Boulevard and Overlook Road, that it never got a house number. A Cleveland newspaper described it in 1910 as a "stately Elizabethan mansion . . . one of the finest residences in Cleveland." It provided an impressive entrance to the Overlook and to Cleveland Heights. In the 1930s, the widowed Maud Stager Eells turned the property over to a family company. Its location made its possible reuses controversial. It eventually became the site of an apartment house. The stone wall remains, as do the servants' quarters and the garage. (See page 114.) (Western Reserve Historical Society.)

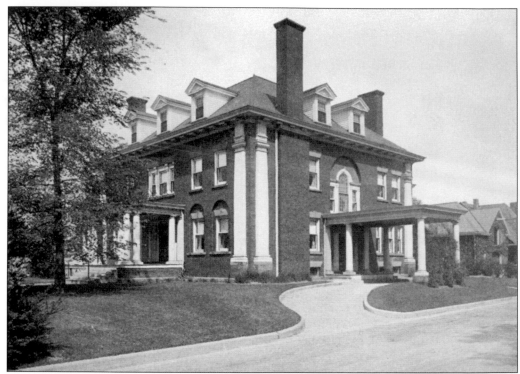

COWLES HOME. According to the Cleveland Architects Database, this handsome Colonial Revival–style home on East Overlook was completed for Cowles in 1899 by architects Meade and Garfield, designers of many homes in this Euclid Heights neighborhood, including Cowles' second home at Derbyshire and Norfolk Roads. Lawyer Virgil P. Kline had purchased this home by 1917. (Case Western Reserve University Special Collections.)

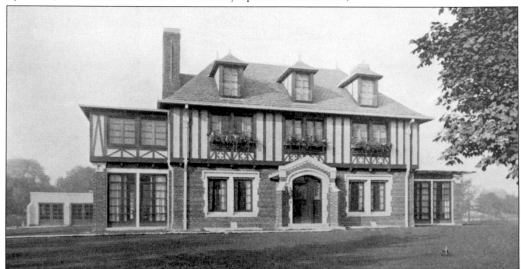

2755 BERKSHIRE ROAD. This Tudor Revival–style home of lawyer Robert M. Calfee illustrates the architectural diversity and distinction of Euclid Heights homes to the east of The Overlook. Built in more contemporary styles, they had broader appeal to new suburbanites than the huge urban mansions planned by Calhoun. (Case Western Reserve University Special Collections.)

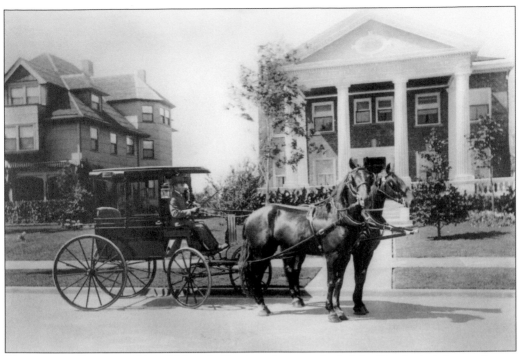

KENILWORTH ROAD, C. 1902. Although Kenilworth never rivaled the Overlook, it boasted some grand homes like this brick mansion of industrialist Daniel Connolly. The horse and carriage are reminders of why homes of this era had carriage houses, which also sometimes housed servants. This house still stands, flanked by an apartment house and a parking lot. (Western Reserve Historical Society.)

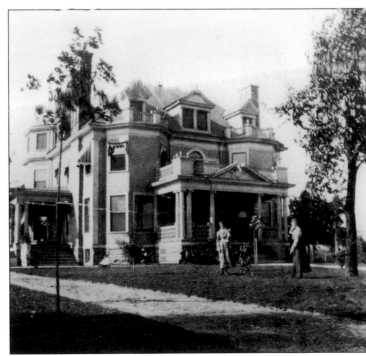

VICTORIAN ON DEVONSHIRE ROAD. Euclid Heights streets often bear English names—like Berkshire, Derbyshire, Norfolk, and Surrey—to suggest what Calhoun and landscape designer Bowditch hoped would resemble an English village. This spacious Victorian home was replaced by two more modest homes in the post–World War II period. (Western Reserve Historical Society.)

BRIGGS ESTATE. The largest estate in Euclid Heights was completed in 1906 for Dr. Charles Edwin Briggs. Margaret Bourke White took this photograph of its garden for *Town and Country Club News*; she also photographed the gardens of Homer H. Johnson. On its site are condominiums. (Western Reserve Historical Society.)

Three

SECOND GENERATION
1910–1929

The second chapter in the life of the Overlook began inauspiciously. In August 1910, William Lowe Rice was murdered at the back of his estate. Police suspected Overlook neighbor and his estranged business partner, John Hartness Brown, of being complicit in the murder. Both had been early agents for Calhoun, and the murder, still unsolved, touched the boulevard with scandal.

In 1911, Calhoun returned from San Francisco after a short, disastrous career as a streetcar magnate and completed the enormous mansion on Berkshire Road, left unfinished since his departure from Cleveland Heights in 1903. Although Euclid Heights streets were already home to socially prominent families, sales in the allotment had slowed during Calhoun's absence, and his Euclid Heights Realty could not pay the interest on its bonds held by Cleveland Trust (a major bondholder was John D. Rockefeller). In 1912, the bank brought suit against the realty company and its stockholders, including homeowners on the Overlook, and obtained the right to market the 400 unsold lots in the allotment. Although his financial difficulties worsened, Calhoun was able to forestall the public auctions until May and September 1914. The last of the Euclid Heights properties, including the Euclid Club, were sold at auction in May 1915. Its golf course was quickly developed as elegant suburban housing.

Members of the Overlook's first families began to move away or die. Their grand urban mansions—less fashionable than the new, less formal homes in the nearby Euclid Golf, Ambler Heights, and Carlton Road developments and the Wade Park allotment at University Circle—became difficult to sell as single-family residences. The first institution—Ursuline College—moved onto the Overlook.

Sharing in the general prosperity of the period and benefitting from new streetcar lines and then more widespread ownership of automobiles, Cleveland Heights' population skyrocketed from 15,264 in 1920 to 50,945 in 1930. Purchasers of Calhoun's unsold properties built single-family homes, duplexes, apartment buildings, and commercial districts, adding complexity and diversity to the growing suburb.

WILLIAM LOWE RICE, 1863–1910. Perhaps one of the masterminds behind Euclid Heights, and an early agent for the company, was the handsome, debonair Rice. A prominent lawyer and man-about-town, Rice specialized in salvaging companies in financial difficulty and making a fortune for himself. On August 4, 1910, as he returned from dinner at the Euclid Club, Rice was stabbed and shot to death. Police interviewed many suspicious persons, focusing upon the few Italian servants and African American laborers in the neighborhood, but came up empty-handed. Rumors suggested that Rice's neighbor and collaborator in Euclid Heights, John Hartness Brown, angered at Rice because of a business deal gone bad, might have arranged Rice's murder. Brown did appear at the murder scene shortly after Rice's body was discovered by passersby. The best account of this, Cleveland Heights' most famous murder (thus far), is by John Stark Bellamy in *They Died Crawling and Other Tales of Cleveland Woe*. (Western Reserve Historical Society.)

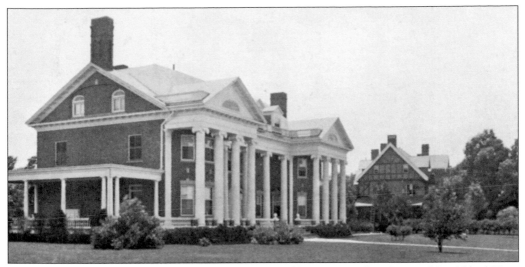

RICE MANSION. Like Calhoun, Rice thought big, and his Lowe Ridge, designed by Alfred Hoyt Granger, reflected his large social ambitions. *House Beautiful* described the newly completed home in 1897 as being "of exceptional size." Parties at the Rice home made the Cleveland society pages. In 1919, Rice's widow sold the home to Fred R. White. The Granger/Johnson home is in the distance. (*Picturesque Cleveland.*)

GARDENS OF LOWE RIDGE. Rice's Lowe Ridge was the largest property on the Overlook, sited on a double lot that extended 700 feet south to Euclid Heights Boulevard. The estate boasted gardens so imposing and elaborate that they appear on plat maps, as do the gardens of Rice's next-door neighbor William P. Palmer. Rice was murdered at the back of his own gardens. (Western Reserve Historical Society.)

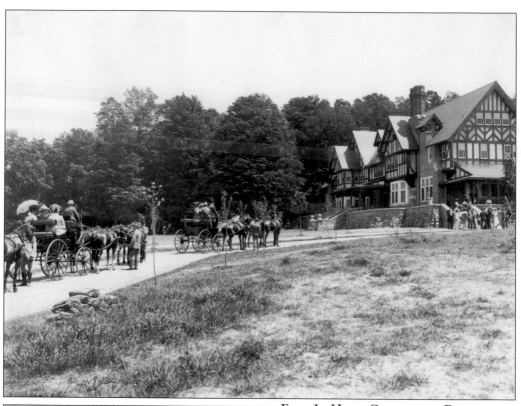

FOUR-IN-HAND CLUB AT THE EUCLID CLUB. Rice was an enthusiastic golfer, horseman, and officer of this fashionable driving club, organized in 1902. Club members and their guests drove through the city's parks and down its residential boulevards, stopping for refreshments along the way. Calhoun's handsome Euclid Club was the destination on this trip. (Western Reserve Historical Society.)

PINKERTON'S NATIONAL DETECTIVE AGENCY.

FOUNDED BY ALLAN PINKERTON 1850.

WM. A. PINKERTON, CHICAGO. } Principals. GEO. D. BANGS, GENERAL MANAGER, New York.
ALLAN PINKERTON, New York. }

—OFFICES.—

NEW YORK	57 Broadway.	CHICAGO	Cleveland	DENVER	Opera House Block.

$10,000 REWARD

Messrs E. J. Blandin, J. B. Zerbe, and Frank H. Ginn offer Five Thousand Dollars ($5,000) reward, and Mr. William Nelson Cromwell offers Five Thousand Dollars ($5,000) additional, for information leading to the arrest and conviction of the murderer or murderers of William L. Rice.

Mr. Rice was shot and killed near his residence on Euclid Heights, Cleveland, Ohio, about 10:40 p. m on August 5, 1910.

Any information imparted will be discreetly investigated, and treated in the strictest confidence.

Under its rules, this Agency or its employees are not permitted to collect, or accept, any reward or part thereof.

Persons receiving this circular will oblige by posting in a conspicuous place.

Kindly send all information to the nearest of the above listed offices by telephone or telegraph at our expense.

PINKERTON'S NATIONAL DETECTIVE AGENCY

410 HIPPODROME BUILDING

August 9th, 1910 Telephones: Main 1409; Cuyahoga Central 1995 CLEVELAND, OHIO

REWARD POSTER. Rice's business partners hired private detectives and offered a generous reward for the arrest of Rice's murderer. Despite a multitude of tips from citizens, sensational stories in the newspapers, and the strenuous efforts of Cleveland and Cleveland Heights police, Rice's killer was never found. (Cleveland State University Special Collections.)

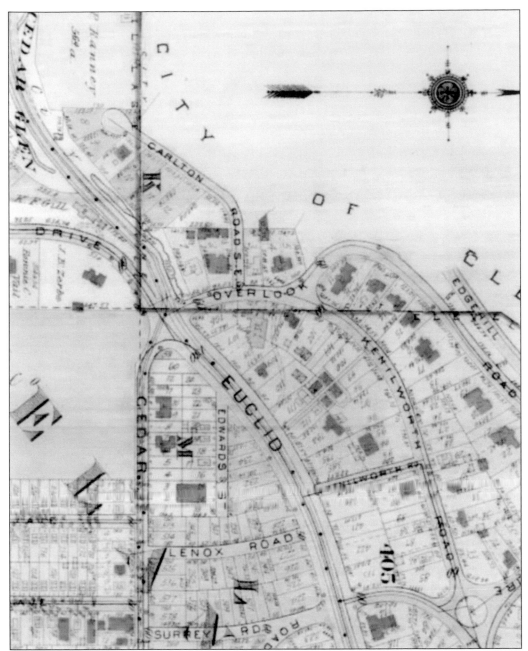

THE OVERLOOK, 1914. This Sanborn map shows the Overlook when it was fully developed. Moving north from the Euclid Heights Boulevard intersection, the following homes appear on the east side of the street: Eells, Rust, Herrick, H. H. Johnson, Chandler, M. B. Johnson, Rice (on the double lot), Palmer, and Alexander. On the west side are Kelley, Cuddy, Dodge, and Sherwin. (The Hinds home does not appear.) The map illustrates the size of the Overlook homes and yards. Carlton Road has already been laid out, and a few homes have been built. Kenilworth Road still intersected with the Overlook between the Rust and Herrick homes, but by 1921, this westernmost section of Kenilworth had been vacated. This street was renamed Herrick Mews in 1975. (See page 117.) (Cleveland Public Library.)

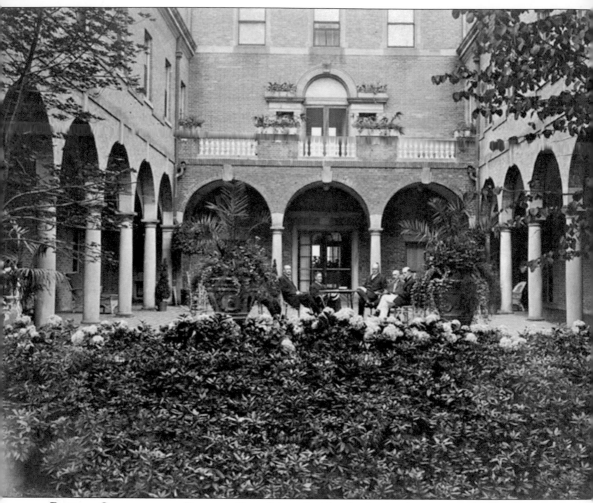

PATRICK CALHOUN AND FRIENDS. Seated in palatial splendor in the courtyard of his home on Derbyshire Road, Calhoun (third from the left) entertained friends and business associates. The mansion was begun in 1903 and completed when he returned to Cleveland in 1911. On the West Coast, Calhoun had created the San Francisco United Street Railways. When its streetcars were damaged by the 1906 earthquake and fire, Calhoun hoped to build a new, improved transit system. In order to get the franchise, Calhoun gave city officials a bribe of $200,000—at least according to a grand jury indictment in 1909. While under indictment, Calhoun also broke a violent strike against his street railway, winning both public support and opprobrium. His sensational trial for bribery resulted in a hung jury and his own tarnished reputation. Nevertheless, he returned to Cleveland hopeful that he could get his Euclid Heights allotment back on firm financial ground. He was unsuccessful, and his major lender, Cleveland Trust, closed in, compelling the public auctions of 1914 and 1915 to satisfy his debts. These photographs were donated to the City of Cleveland Heights by Patricia H. Beall, Calhoun's great granddaughter. They originally appeared in the *Cleveland Leader*. (Patricia H. Beall.)

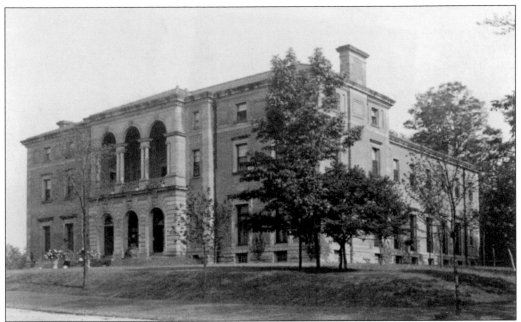

MANSION EXTERIOR. Meade and Garfield designed this enormous house, described by one local newspaper as a "Florentine pile" and by a kinder journalist as "an Italian villa." In her memoir, *Living with Love*, Calhoun's daughter, Mildred Calhoun Wick, remembered it as "the largest residence in Cleveland." It was certainly the largest and most grandiose in Euclid Heights. (Patricia H. Beall.)

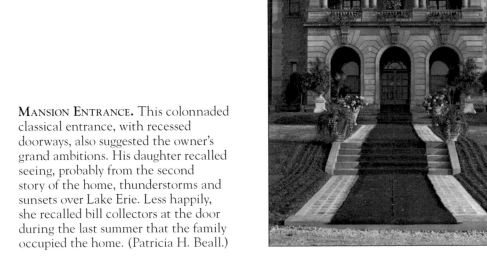

MANSION ENTRANCE. This colonnaded classical entrance, with recessed doorways, also suggested the owner's grand ambitions. His daughter recalled seeing, probably from the second story of the home, thunderstorms and sunsets over Lake Erie. Less happily, she recalled bill collectors at the door during the last summer that the family occupied the home. (Patricia H. Beall.)

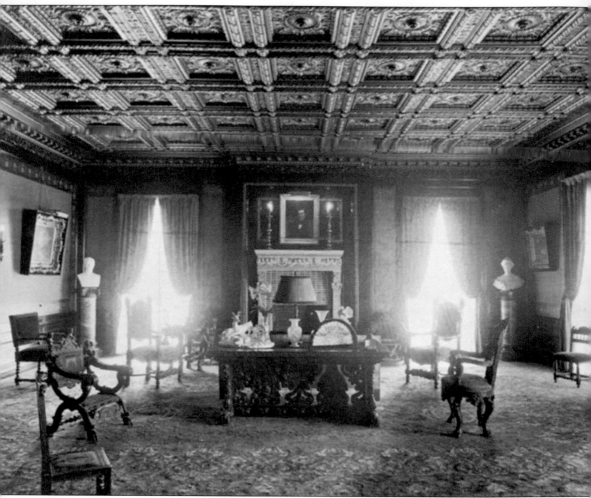

MANSION INTERIOR. The interior was furnished formally and sumptuously, as befitted a man of Calhoun's wealth and social status. Homer H. Johnson, in 1929, remembered the "grand party at its opening. It [was] a wonderful house for entertaining." Almost as soon as the home was completed, however, the Society for Savings, the holder of the home's first mortgage, sought to foreclose on the property. Calhoun retained possession, because the home was in his wife's name. In 1916, the mansion was sold to Dr. George Crile, a prominent surgeon and a founder of the Cleveland Clinic. (Patricia H. Beall.)

SHERIFF'S SALE, 1915.
This brochure advertised
"the way for you to live"
on the Euclid Heights
properties that had not
sold at sheriffs' auctions
in 1914. The photograph
illustrates the curving,
tree-lined streets that had
become the hallmarks
of the allotment.
(Western Reserve
Historical Society.)

 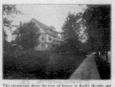 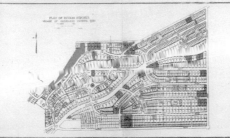

Big Opportunity

Many beautiful lots in Euclid Heights Allotment will be offered at Sheriff's Sale, Tuesday, May 18th.

One Million Two-Hundred Thousand Dollars worth of property sold at the sale last year to satisfied buyers, is a good indication of values and speaks for itself.

Beautiful new homes have been erected; many others are now in course of construction or are contemplated.

Single and contiguous lots in all sizes and range of cost, well and desirably located. Study the map and attend this—probably the last—Sheriff's Sale at Euclid Heights Allotment.

Chance Makes This Opportunity. A Sheriff's Sale in an Established Residence District doesn't happen every day. Your chance to live in Euclid Heights becomes a real opportunity on May 18th

Values Going Up

Rising population means rising real estate values. Cleveland is growing. Really choice residence districts—from the viewpoint of convenience, desirability and known environment—are scarce.

Euclid Heights has all the advantages, good transportation and accessibility to the business heart of the city, pure air, freedom from undesirable encroachments, healthful altitude, quiet, refined and established environment, and every feature that counts for permanent satisfaction in a home site.

Choose your location from this map. The colored portions show the lots that must be sold. Visit the property in advance. Get any additional information you may need for your decision. And don't fail to be on the grounds at the sale—Tuesday, May 18th, from 9:00 A. M. to 3:30 P. M.

REMAINING PROPERTIES, 1915. The shaded areas on the map indicate properties still unsold, and the photographs illustrate the varieties of housing sites still available. Purchasers built single homes, duplexes, apartment buildings, and two shopping centers, transforming what had been intended as an exclusively residential allotment into a vibrant and diverse neighborhood. (Western Reserve Historical Society.)

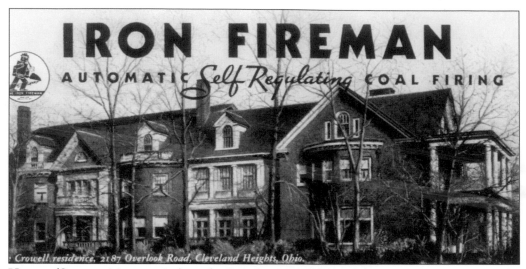

Crowell residence, 2187 Overlook Road, Cleveland Heights, Ohio.

HERRICK/CROWELL MANSION. Industrialist Benedict Crowell became the owner of Myron T. Herrick's home on the Overlook when Herrick went to France as U.S. ambassador. Crowell allowed his home to be used to advertise the "Iron Fireman" heating system. (City of Cleveland Heights.)

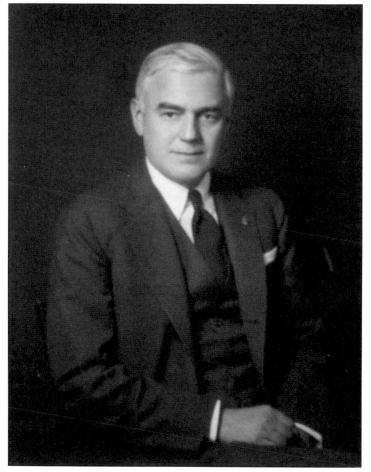

DAVID L. JOHNSON, 1888–1951. After Melvin B. Johnson died, his son David L. Johnson bought the home at 2141 Overlook Road, after his mother tried unsuccessfully to sell it. After the next-door neighbors George N. Chandler and his wife died, George R. Chandler bought his parents' home at 2155 Overlook Road and probably replaced the home built for Dr. O. F. Gordon with the existing French Norman structure. (See pages 111 and 112.) (Author's collection.)

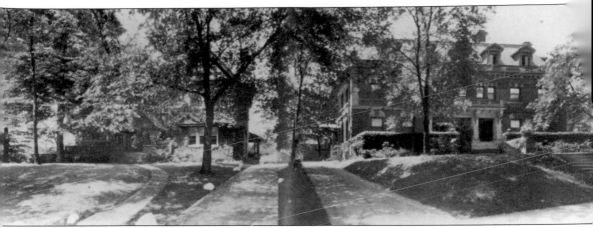

BEAUMONT AND MERICI HALLS, URSULINE COLLEGE. After Hermon Kelley's death, his home was advertised for sale as "an ideal apartment or family hotel site . . . The Price is less than the value of the lot alone. This is a bargain." Ursuline College agreed, buying also the Loftus Cuddy/A. S. Gilman mansion next door. Ursuline was chartered in 1871, making it the first college chartered for women in Ohio. It moved to the Overlook from a rented building on Euclid Avenue next to Severance Hall. Beaumont Hall, the administration and academic building, was named after Mother Mary of the Annunciation Beaumont, who led the first group of Ursulines to Cleveland in 1850. Merici Hall, the former Cuddy/Gilman mansion, housed the library and living quarters for nuns and a few students. From 1902 to 1921, the college educated nuns to teach in Cleveland's proliferating parochial schools, but in 1922, reopened the institution to laywomen. The resulting growth in enrollment encouraged the college to move up the hill to the Overlook. The Ursulines also established Beaumont School in Cleveland Heights in 1942. (Ursuline College Archives.)

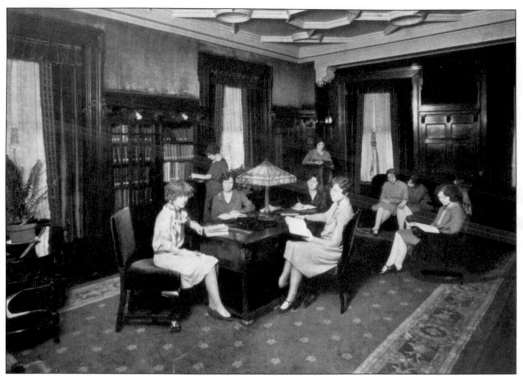

MERICI HALL, INTERIOR. This studious group, the Booknook Club, met in what had probably been the library of the Cuddy mansion. Ursuline's four-year course of study offered bachelor's degrees in arts, sciences, and letters as well as certification for teaching high school. (Ursuline College Archives.)

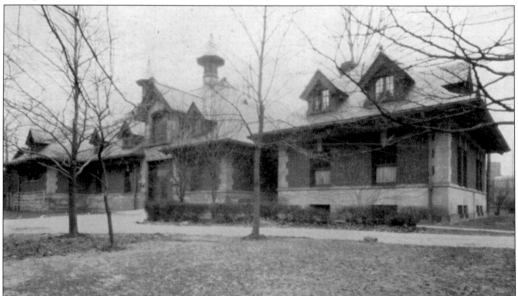

SCIENCE HALL. This handsome building, directly behind Merici Hall, was probably the Cuddy carriage house. The center of the building became the college gymnasium, flanked by the biology and chemistry laboratories. (Ursuline College Archives.)

KENILWORTH AND DERBYSHIRE ROADS. This home, reminiscent of an Italian villa, is identified in *Beautiful Homes of Cleveland, 1917* as the home of Harry Payer. It still stands at this site, although it is now enclosed by a brick wall. (Case Western Reserve University Special Collections.)

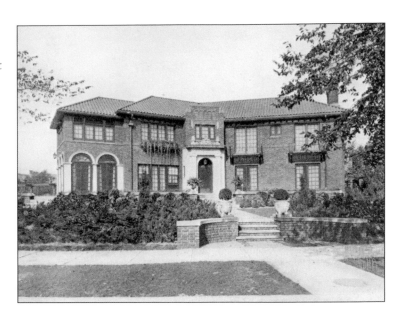

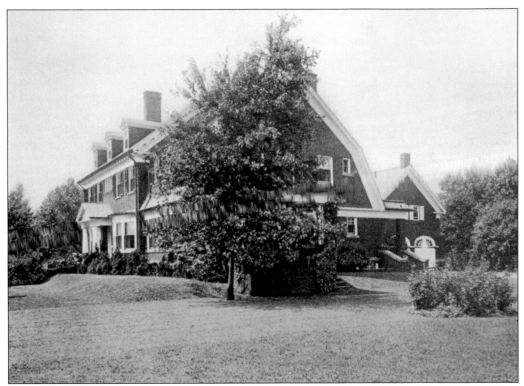

2441 EUCLID HEIGHTS BOULEVARD. Euclid Heights Boulevard also became the site of fine architect-designed homes in fashionable styles. According to *Beautiful Homes of Cleveland, 1917,* this brick Colonial home belonged to Horace Andrews. Its site at the intersection of Euclid Heights Boulevard and Derbyshire Road is now a small park. (Case Western Reserve University Special Collections.)

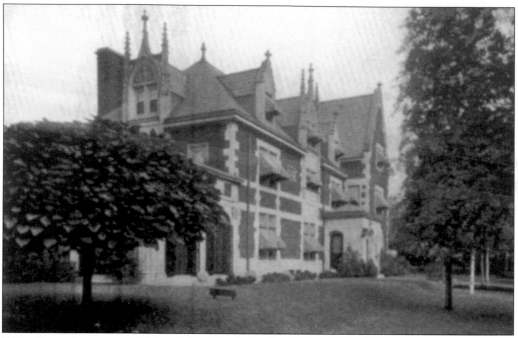

WADE PARK ALLOTMENT. This neighborhood, developed during the 1910s by Jeptha Homer Wade Jr., competed with the Overlook for wealthy homeowners, who wanted homes in a variety of styles and sizes, as indicated here by the formal Glidden mansion and the more modest Everett home. Wade's allotment had the advantage of its proximity to the Wade Lagoon, Rockefeller Park, the two colleges, and the new Cleveland Museum of Art. Many of the allotment's first homes are now owned by Case Western Reserve University or other nonprofit institutions. The Glidden home is a hotel. (Both photographs, Case Western Reserve University Archives.)

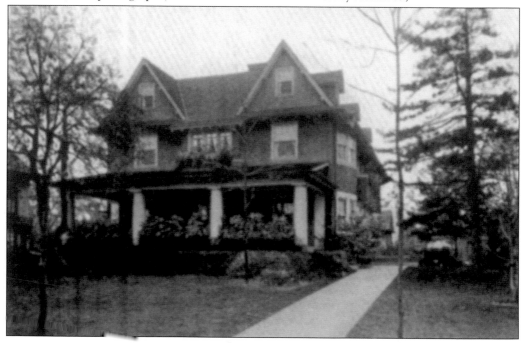

AMBLER HEIGHTS, C. 1909.
Across Cedar Glen from
the Overlook, Dan Caswell
developed this elegant allotment
that had been laid out in the
1890s by Dr. Nathan Ambler.
Its homes—like this handsome
brick Colonial by Meade
and Hamilton, completed
in 1906—were gracious
but designed for informal
suburban living. The home
and the fashionable electric car
belonged to the E. B. Brown
family. (Sally Fahrenthold.)

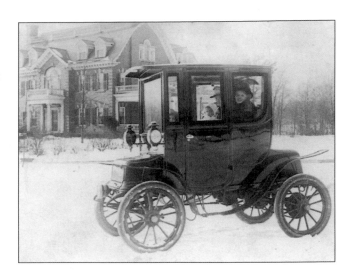

Some Euclid Golf Homes

The Euclid Golf Neighborhood

*I*N PURCHASING a home in Euclid Golf you do more than purchase
a mere piece of land of great natural beauty, furnished with high
grade permanent improvements, and so located as to street car
and general accessibility as to make it the most location
for a home in Cleveland. You get all that in Euclid Golf ... will get
something far more

...... get it ahood interest that is expressed in well
kept,ly treated homes, a general wholesome neighborliness
... a pride in community that is enthusiastic, spontaneous and sincere.
It is this intangible yet noticeable atmosphere of neighborhood interest,
which even the stranger feels in driving through the streets that makes
Euclid Golf the place where more and more Clevelanders of culture
and refinement want to make their homes.

The B. R. Deming Co.

EUCLID GOLF HOMES. These homes, built on the former golf course of the Euclid Club and along
the streetcar line that ran up Fairmount Boulevard, also competed successfully for new suburban
families who wished to live with other "Clevelanders of culture," but not in enormous mansions
on the Cleveland border. (Western Reserve Historical Society.)

HOME ON 11896 CARLTON ROAD. Carlton Road ran west off the Overlook between the Cuddy and Dodge homes. This property had been purchased in the 1886 by James W. Lee and was laid out as a single-street residential development by his son James W. Lee, in 1910. The distinguished firm of Walker and Weeks designed this Colonial home and 6 of the 13 houses on the cul-de-sac. (Case Western Reserve University Archives.)

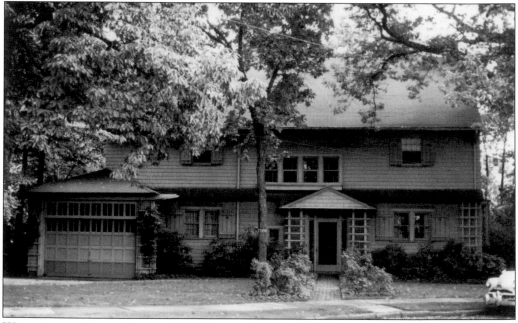

WALKER AND WEEKS HOME, 11898 CARLTON ROAD. Like the Ambler Heights homes, these gracious structures, designed in American styles, were the wave of the suburban future. The Overlook's ponderous, solemn urban mansions with carriage houses for horses and servants had become outmoded. (Case Western Reserve University Archives.)

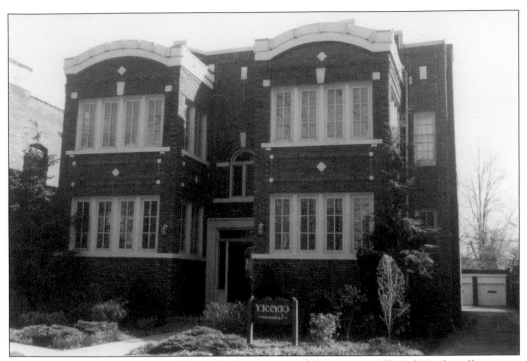

APARTMENT AT 2460 OVERLOOK ROAD. At the auctions of the remaining Euclid Heights allotments, several purchasers bought large pieces of property on Overlook to the northeast of the residential boulevard, on which they built apartment buildings. This small four-unit building on the south side of the street, completed in 1915, was designed by S. H. Weis. (City of Cleveland Heights.)

APARTMENTS AT 2509–2517 OVERLOOK ROAD. Almost as grand as the mansions on the Overlook, these double apartments, separated by a courtyard, boast handsome bay windows and decorative stonework. The buildings were completed in 1924. (City of Cleveland Heights.)

HEIGHTS CENTER BUILDING. An early commercial building in the Cedar-Fairmount shopping center, this was completed in 1916. Streetcar lines up Cedar Road and Fairmount Boulevard made the location commercially successful. The architectural firm of Richardson and Yost added European touches, such as the decorative stucco, that made the building and the commercial area unique. The building is a Cleveland Heights landmark. (City of Cleveland Heights.)

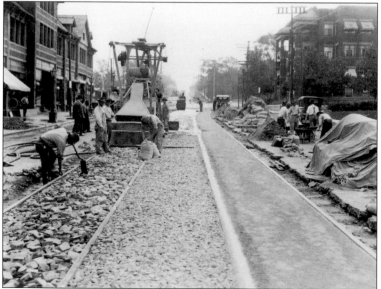

CEDAR ROAD STREETCAR, 1918. Extending Calhoun's Cedar Glen streetcar, the Cleveland Railway Company ran its lines up Fairmount Boulevard and Cedar Road. The Heights Center Building can be seen on the left. The apartment buildings on the right would soon be demolished. (Western Reserve Historical Society.)

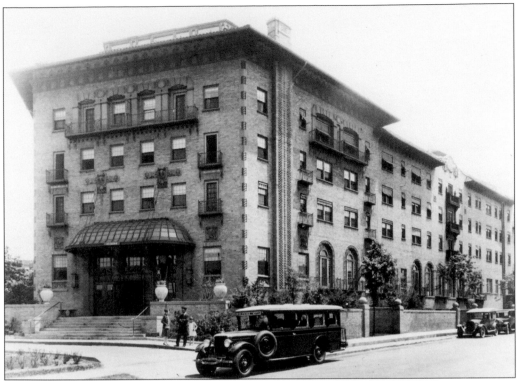

ALCAZAR HOTEL. Designed by H. T. Jeffery and completed in 1923, this stylish Spanish-Moorish hotel, along with the Heights Center Building, helped to establish the cosmopolitan tone of the Cedar-Fairmount shopping center. Still the only hotel in Cleveland Heights, the Alcazar Hotel is a Cleveland Heights landmark and is listed on the National Register of Historic Places. (City of Cleveland Heights.)

CEDAR FAIRMOUNT SHOPPING DISTRICT. The Heights Medical Building on the left has replaced the Fairmount Boulevard apartment buildings, and the district had developed a full complement of shops and offices by 1940. The district was served by both streetcars and automobiles. (Western Reserve Historical Society.)

VIEW OF 1800 COVENTRY ROAD. Coventry constituted the easternmost boundary of the Euclid Heights allotment and developed as a commercial area only after Calhoun lost control of the property. The development of the neighborhood was encouraged by the streetcar that ran north and south along Coventry Road from Euclid Heights Boulevard to Mayfield Road. (City of Cleveland Heights.)

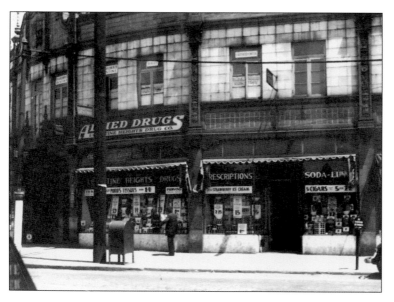

COVENTRY AND MAYFIELD ROADS. Because of its proximity to the Jewish neighborhood of Glenville in Cleveland and to Jewish institutions, such as the Montefiore Home and B'nai Jeshurun (Temple on the Heights) on Mayfield Road, Coventry developed as a Jewish neighborhood during the 1920s. (City of Cleveland Heights.)

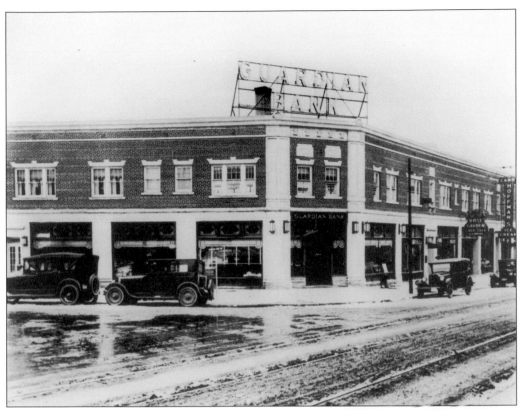

COVENTRY AND LANCASHIRE ROADS. The Guardian Bank occupied this central location until it was closed during the 1933 Bank Holiday. There is a Key Bank currently at this site, but the Rose Garden Restaurant and Hoffman's candy and ice cream store have long since vanished. (Western Reserve Historical Society.)

HAMPSHIRE ROAD DUPLEXES. Also part of the original Euclid Heights allotment, property along Hampshire Road west of Coventry was purchased for small apartments and these double homes. With uniform setbacks and welcoming front porches, these homes and yards create an attractive, coherent streetscape. (Author's collection.)

Cedar Glen Parkway. The view of the Overlook at the end of the 1920s would have appeared familiar to Calhoun. The homes on the left—those of Kelley, Cuddy, Dodge, and in the distance, Sherwin—still stood, as did the Eells mansion behind its walls. What Calhoun could not have seen from this distance is that the Kelley and Cuddy homes had been purchased by Ursuline College, the first institution on the Overlook. (Perhaps those women waiting for the streetcar were Ursuline students.) He could also not have seen even the greater, imminent changes to the Overlook and to Cleveland Heights. (Nottingham Spirk and Design.)

Four

DECLINING FORTUNES
1929–1949

The Depression and World War II battered the city and the suburb. Kept afloat by federal public works projects, Cleveland and Cleveland Heights emerged from war intact, but irretrievably altered. The national emergencies also hastened the decline of Calhoun's once-elite residential boulevard. When Cleveland factories shut down during the 1930s, and then when wartime exigencies created a shortage of servants and other accoutrements of fine living, the huge urban mansions of the Overlook, built for a different era, seemed extravagant and obsolete to some of the founding families. William P. Palmer's mansion was demolished, and his elegant gardens lay untended well into the 1940s. After his death, John Sherwin's home became a social club until it was purchased by Ursuline College in 1944. The widow of Howard P. Eells turned her mansion over to a family corporation; neighbors successfully fought off the efforts of a Jewish congregation and then a veterans hospital to buy the Eells' home. Multifamily housing became a solution to the postwar housing shortage. Several of Cleveland Heights's largest mansions briefly became boarding houses, including the Rice/White home. New duplexes were constructed at the far north end of the Overlook on the very edge of the bluff.

In 1949, the Overlook was still lined with most of the original mansions; they were carefully maintained by Ursuline College and the new owner of the Herrick/Crowell home, Overlook House, a Christian Science nursing facility. The Howell Hinds mansion had been replaced by the magnificent First Church of Christ, Scientist, the Overlook's second institution. More institutions and multifamily housing would follow.

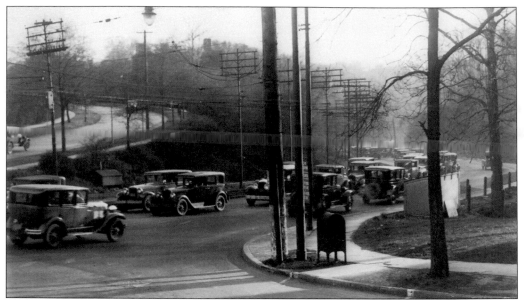

TRAFFIC JAM, OVERLOOK ROAD AND CEDAR GLEN PARKWAY. By the end of the 1920s, no one would have claimed, as had Calhoun's early advertisements, that the air on the Overlook was "pure, exhilarating, and healthful." Cedar Glen had become a congested commuter highway for suburbanites heading farther and farther east up Euclid Heights and Fairmount Boulevards and Cedar Road. The Overlook had become a less and less desirable place to live. (Cleveland State University Special Collections.)

PRESIDENT'S HOME, 11893 CARLTON ROAD. Western Reserve University made its first inroads into the neighborhood when it leased this home for the university president from 1929 to 1936 from Bascom Little. Four decades later, Case Western Reserve University bought and demolished this and other Carlton Road homes to expand its campus. (Case Western Reserve University Archives.)

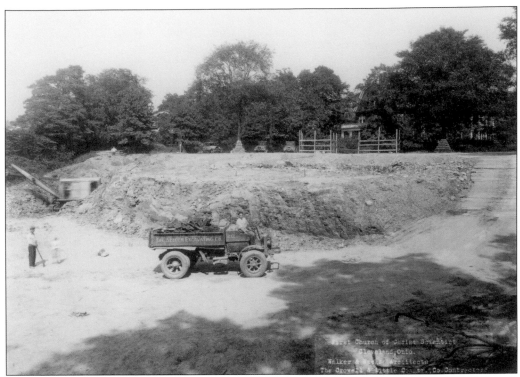

CONSTRUCTION, FIRST CHURCH OF CHRIST, SCIENTIST, CLEVELAND, 1929. The widow of Howell Hinds sold their home to this congregation in 1928, and after the home's demolition, construction for the church began in 1929. Walker and Weeks did the design; the contractors were Crowell and Little. Visible in the distance is the home of Benedict Crowell (formerly the Herrick mansion), which would become Overlook House in 1948, a Christian Science nursing facility. (Nottingham Spirk and Design.)

FIRST CHURCH OF CHRIST, SCIENTIST, CLEVELAND, 1929. The photograph captures the challenges of constructing the church that partially descended the steep slope that had been the Hinds' backyard. (See page 35.) The two workers are dwarfed by the enormous structure. (Nottingham Spirk and Design.)

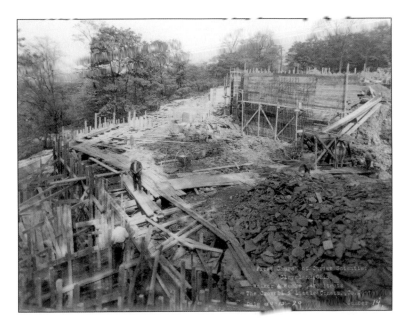

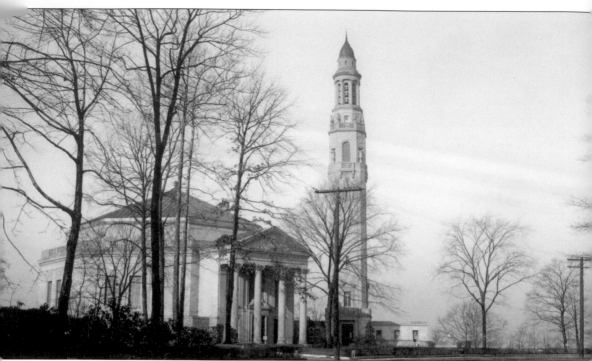

FIRST CHURCH OF CHRIST, SCIENTIST, CLEVELAND, 1931. When completed, the neoclassical building with its octagonal auditorium closely resembled Severance Hall, also designed by Walker and Weeks. The church was sometimes referred to as "Little Severance." The congregation was organized in 1888 and moved to the Overlook from Euclid Avenue and East Eighty-third Street. In 2003, the congregation merged with a Cleveland Heights congregation and sold the building to Nottingham Spirk and Design. The lighted campanile, visible for miles, still calls attention to the splendid building and the Overlook. (Nottingham Spirk and Design.)

CEDAR GLEN PARKWAY PLAQUE, 1931. The plaque celebrates the construction of the handsome stone wall on the north side of Cedar Glen and the widening of the roadway. "The rejuvenated gateway to Cleveland Heights," exclaimed the *Heights Press* in October 1931. The improvement was a joint effort by the cities of Cleveland and Cleveland Heights, Cuyahoga County, and the Cleveland Railway Company, whose streetcars ran up and down the hill. (Author's collection.)

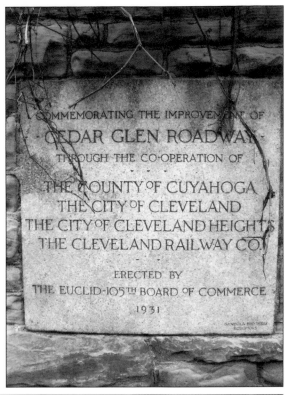

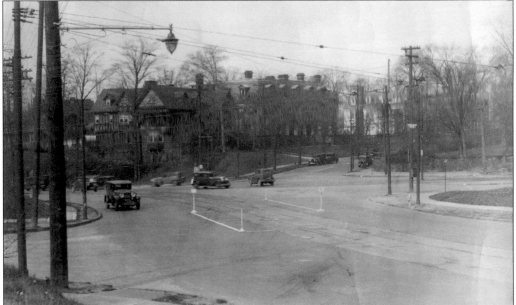

CEDAR GLEN PARKWAY, C. 1935. In the earliest years of the Depression, the officials of Cleveland Heights had put unemployed residents to work on small projects in the city's parks. In 1933, as the Depression worsened, the federal Civil Works Administration put many more Cleveland Heights men to work on a much more substantial project, widening and landscaping Cedar Glen. The Ursuline College buildings appear on the crest of the hill. (City of Cleveland Heights.)

75

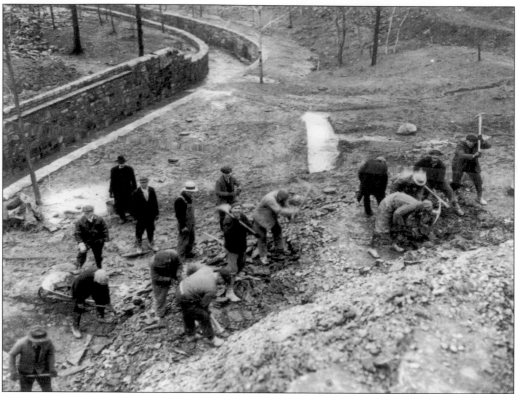

Works Progress Administration at Cain Park. The federal Works Progress Administration (WPA) provided more substantial aid than the Civil Works Administration, and WPA workers dug culverts and built the tennis courts and pavilion at Cain Park. Although Cleveland Heights funded its own small relief projects and provided aid to needy residents, federal dollars for relief and work ultimately rescued the city. (Western Reserve Historical Society.)

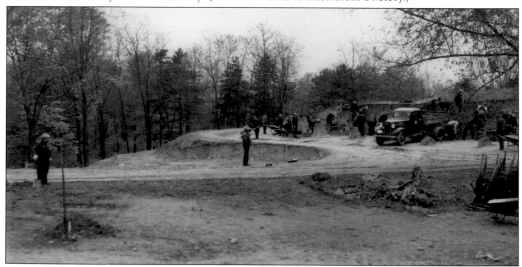

WPA at Forest Hills Park. The federal agency also put hundreds of men to work on Forest Hill Park, which John D. Rockefeller had just donated to the cities of Cleveland Heights and East Cleveland. (City of Cleveland Heights.)

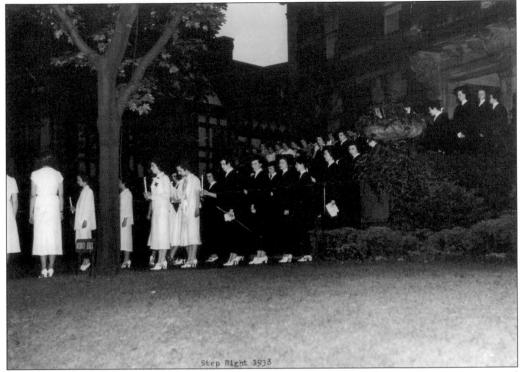

Step Night 1938

URSULINE COLLEGE STEP NIGHT, 1938. This annual event honored graduating seniors who stepped forward toward their future as the three lower classes stepped forward to take their places. The ceremony took place on the steps in front of Merici Hall, formerly the Cuddy/Gilman mansion. Despite the Depression, the college's enrollment held steady at about 200 students during the 1930s. (Ursuline College Archives.)

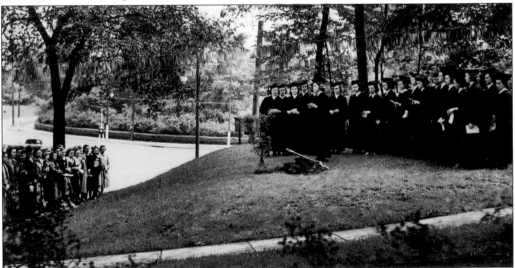

URSULINE COLLEGE TREE DAY, 1938. Every year, the sophomore class planted a tree on the lawn of Beaumont Hall, formerly the Kelley mansion. The photograph illustrates the college's visibility at the intersection of the Overlook and Cedar Glen. On this site now are the Case Western Reserve University tennis courts and perhaps some Ursuline trees. (Ursuline College Archives.)

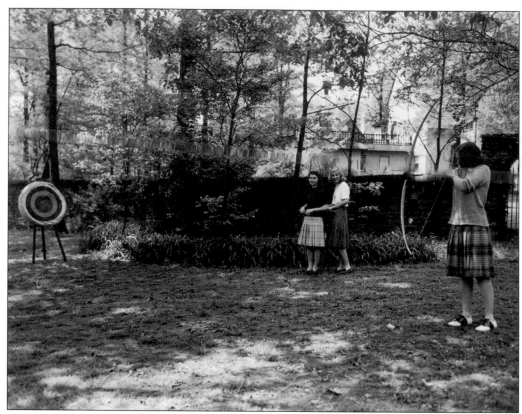

URSULINE ARCHERS, 1942. This archery contest took place in the garden behind Beaumont Hall. A portion of this lovely wall has survived. (See page 113.) Ursuline students participated enthusiastically in the war effort, selling enough war bonds for Ursuline to rank first in Ohio and fourth in the country for a women's college of its size. (Ursuline College Archives.)

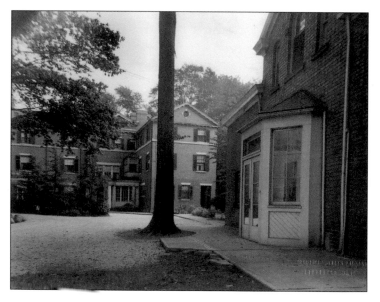

URSULINE COLLEGE'S AMADEUS HALL. In 1944, anticipating rising enrollment, the college bought the John Sherwin mansion for a dormitory, which it named Amadeus Hall. At the right is the former Sherwin carriage house, which the college renovated and opened in 1946 as a smaller dormitory, Brescia Hall. The dormitories were demolished, along with the other Ursuline buildings, in 1968. (Ursuline College Archives.)

INSTITUTIONS ON THE OVERLOOK. As seen on this Sanborn map, the first two institutions on the Overlook soon dominated its landscape. In the center is the large footprint of the First Church of Christ, Scientist, Cleveland, on its 4-acre site. To its immediate right is the campus of Ursuline College, which, by 1944, owned three of the four homes and their carriage houses on the Overlook south to Cedar Glen. The map also shows the proximity of the Overlook to the closely built homes of Little Italy to the immediate west and down the bluff. (dmc.ohiolink.edu.)

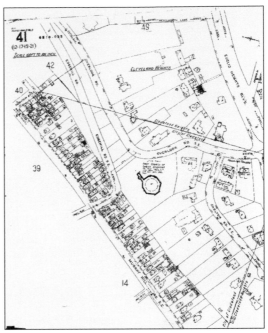

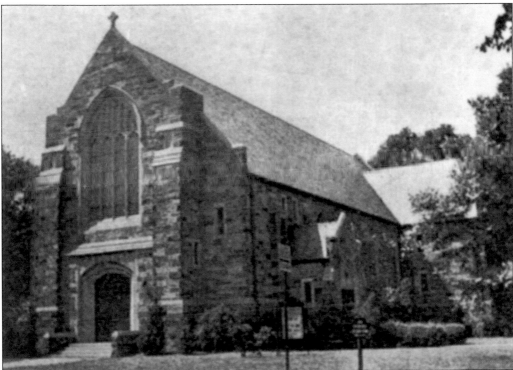

FIRST ENGLISH LUTHERAN CHURCH. Another congregation joined the neighborhood when the First English Lutheran Church bought the vacant property at the corner of Derbyshire Road and Euclid Heights Boulevard, adjoining what had been the William Lowe Rice property, in 1932. The congregation moved into the building, which, because of Depression-induced financial difficulties, remained unfinished until 1936. (Rev. Robert Hanson.)

LAURENCE H. AND ROBERT C. NORTON. The Norton brothers bought the John F. Rust Jr. home in 1939, bringing with them the Venetian lions that had graced the front steps of their family home on Euclid Avenue. (See page 40.) They were the brothers of Mariam Norton White, who lived in the mansion built for Rice. Laurence H. Norton (left) had been secretary to Myron T. Herrick when Herrick was ambassador to France and then became director and treasurer of the Oglebay Norton Company; he was also a longtime president of the Western Reserve Historical Society. When he died in 1960, the home became the property of Case Institute of Technology, then on its move up the hill. The home finally became an apartment for the nurses at Overlook House before its demolition in 1973. (See page 100.) (Cleveland State University Special Collections.)

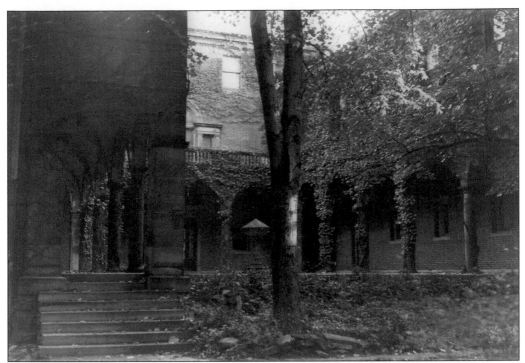

CALHOUN/CRILE MANSION. In 1943, Dr. George Crile's widow wanted to sell the enormous home (see page 55) to an Orthodox Jewish rabbinical college. Although the college promised to keep the home intact, neighbors successfully fought off this incursion into their Euclid Heights neighborhood. This is now the site of Cedar Hill Baptist Church. (Cleveland Public Library.)

WORLD WAR II MEMORIAL. This simple wood and stone structure at the foot of Cumberland Park lists the names of the 5,400 Cleveland Heights men and women who served in the armed forces during this war. Overlook residents, their children, and grandchildren also served in the armed services, and like other Cleveland Heights neighborhoods, the Overlook organized a block club that supported the war effort. (Cleveland State University Special Collections.)

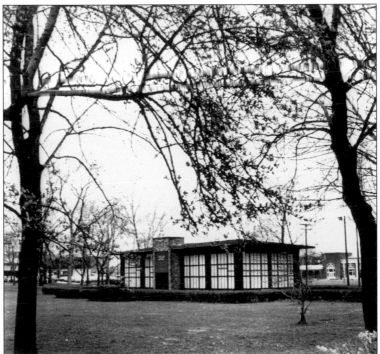

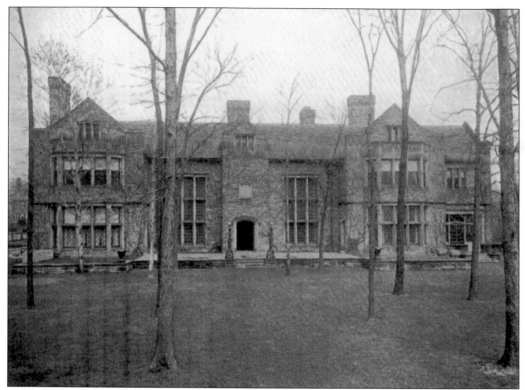

EELLS MANSION. When Maud Stager Eells moved, the mansion became the property of a family corporation. In 1943, a Jewish congregation and in 1948, a veterans hospital proposed buying the property, but Overlook residents and neighbors rallied successfully against both proposals. Its prominent site at Overlook Road and Euclid Heights Boulevard gave the home symbolic importance as one of the grand mansions of Cleveland Heights. The property is now the site of an apartment building. (See page 93.) (Case Western Reserve University Special Collections.)

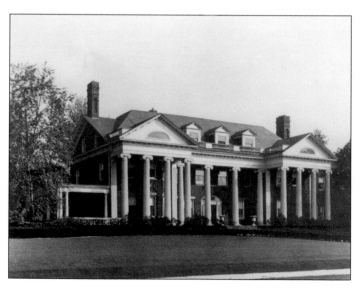

RICE/WHITE MANSION. The housing shortage turned several large homes in Cleveland Heights into multifamily residences. City officials complained in 1947 about a "rooming house racket," but when the editor of the *Heights Press* visited the Rice/White home, then operated by a Mrs. Snow as a home for GIs and students, he found it "spotless and orderly." Waldorf Towers now occupies the site of the Rice/White and the Palmer mansions. (Western Reserve Historical Society)

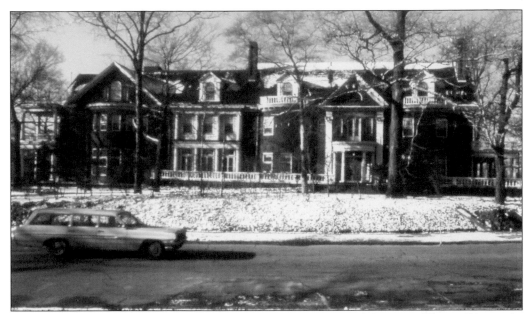

OVERLOOK HOUSE. In 1948, Northern Ohio Trustees Inc. purchased the Herrick/Crowell home for a Christian Science nursing facility dedicated to the basic principles of Christian Science nursing: "[N]ourishing, nurturing, and cherishing . . . Comforting, supporting, encouraging . . . treating with tenderness and affection, holding as dear. . . . [T]he expression . . . of God's mothering care for His children." The facility admitted its first patients in 1950. (Jean Breitzmann.)

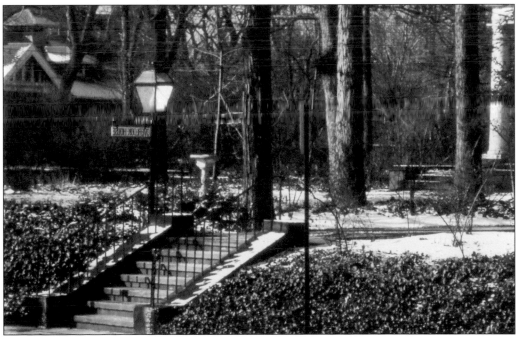

OVERLOOK HOUSE STAIRS. This graceful stairway led from the nursing facility, one of only five Christian Science nursing facilities in the country, through the landscaped grounds to the Overlook sidewalk. To the left is the Homer H. Johnson home that the corporation also purchased and razed. (Jean Breitzmann.)

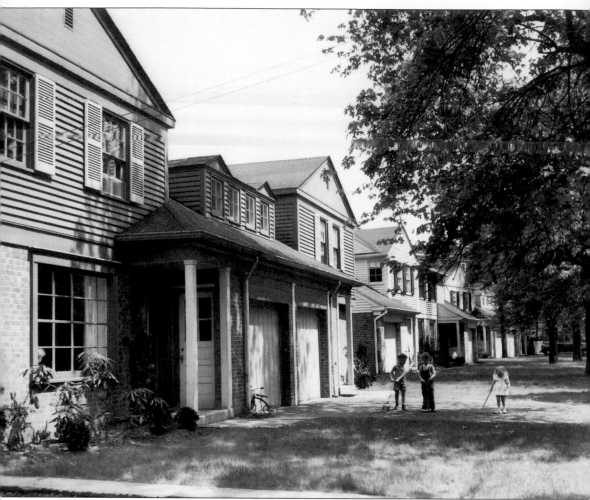

NEW NEIGHBORS. The postwar housing shortage also inspired the building of these duplexes in 1947 on a strip of land perched on the very edge of the bluff that had originally been part of the Brown/Sayle property. The attractive Colonial Revival homes were built by Leonard Gunderson, who also constructed several homes in the postwar Forest Hill allotment in the same style. The local paper referred to the duplexes' residents as "cliff dwellers," but the homes' proximity to University Circle and the view of Lake Erie made them attractive to young families and the faculties of Case Institute of Technology and Western Reserve University. The appearance of multifamily housing on the properties of the first families of the Overlook—even at its northernmost edge—would be the wave of the boulevard's future. (Cleveland State University Special Collections.)

Five

NEW RESIDENTS
1950–1975

Cleveland's population peaked in 1950; Cleveland Heights' population shot up a decade later. In short order, however, both populations declined as the city's industrial base eroded, and jobs and residents left for greener pastures on new federal highways. This quickening exodus took with it the last of the Overlook's founding families. Into their old mansions moved new residents, nonprofit and social service agencies, including the College Club of Cleveland, the Catharine Horstmann Home for women, and the United Cerebral Palsy Foundation. Multifamily dwellings replaced old single-family homes. Two large apartment buildings were constructed where the Palmer, Rice, and Eells mansions had stood. Former servants quarters and carriage houses became rental units. After 40 years on the Overlook, Ursuline College also migrated east to Pepper Pike. Case Institute of Technology (now Case Western Reserve University), enjoying postwar prosperity and a growing student body, moved up the hill from University Circle and bought and razed homes on Carlton Road and the Ursuline College buildings on the Overlook. Neighbors contested the university's plan to build residence halls and fraternities, but both Cleveland and Cleveland Heights ultimately agreed to the necessary rezoning in 1966. The demolition or reuse of these mansions marked the end of an era.

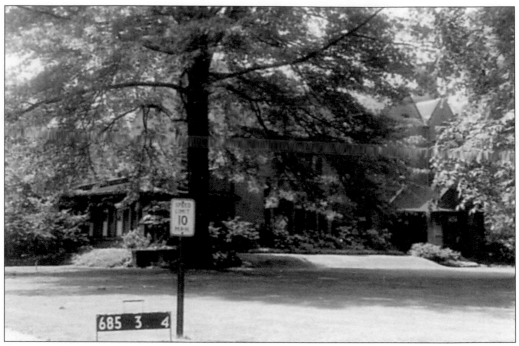

COLLEGE CLUB OF CLEVELAND, 2348 OVERLOOK. In 1951, the club bought the Alexander/ Dangler mansion for $27,000; it had stood vacant for two years. The organization renovated the home's interior and replaced the gardens with a parking lot. The club was established in 1897 for college-educated women with philanthropic and literary interests; Louise Pope Johnson, wife of Homer H. Johnson, was a founder. The photograph was taken by Cuyahoga County in 1958 for its inventory of the county's structures. (Cuyahoga County Archives.)

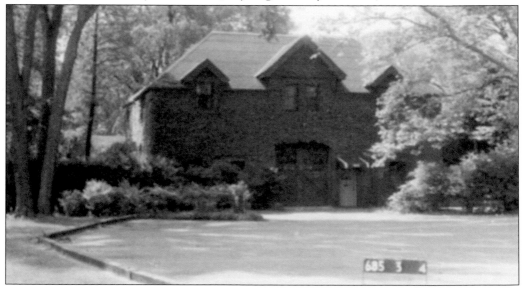

COLLEGE CLUB REAR APARTMENT, 2350 OVERLOOK. The Alexander/Dangler carriage house had become a separate apartment by 1958, when the county took this photograph. The handsome carriage house was designed by Meade and Garfield in the same style as the mansion. The club purchased the building in 1975. (Cuyahoga County Archives.)

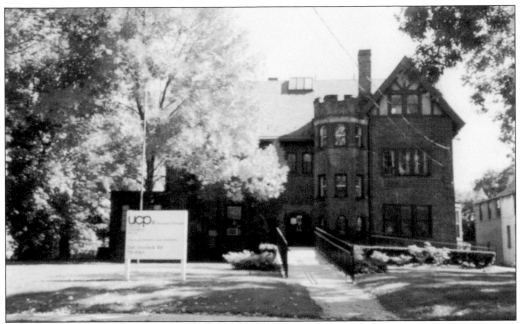

UNITED CEREBRAL PALSY FOUNDATION, 2141 OVERLOOK. The foundation bought the Granger/Johnson home in 1952. To accommodate its clients, the foundation added two ramps and enclosed the side porch to enlarge the first floor. This, and the Alexander/Dangler and the Brown/Sayle homes, are the only three of the original Overlook mansions that have survived. (Author's collection.)

UNITED CEREBRAL PALSY FOUNDATION BACKYARD. The home's backyard was also altered, turning the formal gardens into a playground for children who attended nursery school there. Today the foundation offers preschool education, individual and family counseling, and occupational, physical, speech, and language therapy. (United Cerebral Palsy Foundation.)

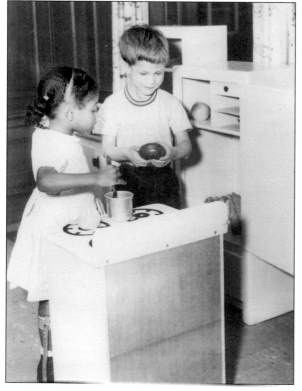

UNITED CEREBRAL PALSY FOUNDATION NURSERY SCHOOL. The foundation was established in 1950 by parents of children with cerebral palsy. Its goal is to "advance the independence, productivity and full citizenship of people with cerebral palsy and other disabilities." (United Cerebral Palsy Foundation.)

UNITED CEREBRAL PALSY FOUNDATION CHILDREN. Believing that their goal can be best achieved by reaching children early, the foundation provides a variety of special services for children, such as this nursery school, as well as vocational and residential services for adults. In 1998, the foundation sold the Overlook property and moved to 10011 Euclid Avenue. (United Cerebral Palsy Foundation.)

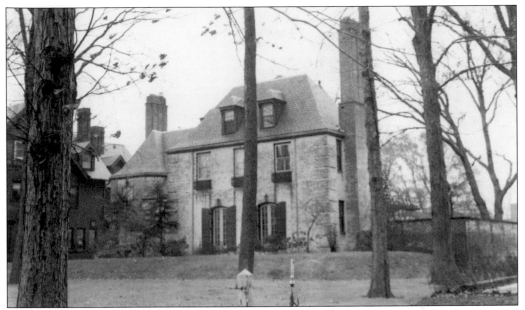

CATHERINE HORSTMANN HOME, 2155 OVERLOOK. The agency purchased the John R. Chandler home in 1951. At the left is the United Cerebral Palsy Foundation property. The wall at the right of the Horstmann home has been demolished. Across the street from Ursuline College, the home became the second Catholic institution for women on the Overlook. (Cleveland Catholic Diocesan Archives.)

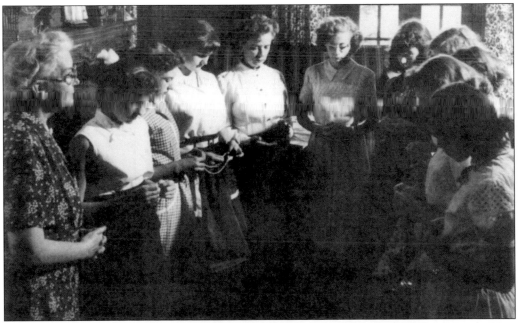

CATHERINE HORSTMANN RESIDENTS, C. 1953. The home was established in 1907 for young working women, and when this photograph was taken, it sheltered dependent high school girls. It was named for the mother of Bishop Ignatius Horstmann and was originally staffed by the Sisters of the Good Shepherd. The young women and their housemother sustained its Catholic identity by observing Catholic rituals such as saying the rosary. (Cleveland Catholic Diocesan Archives.)

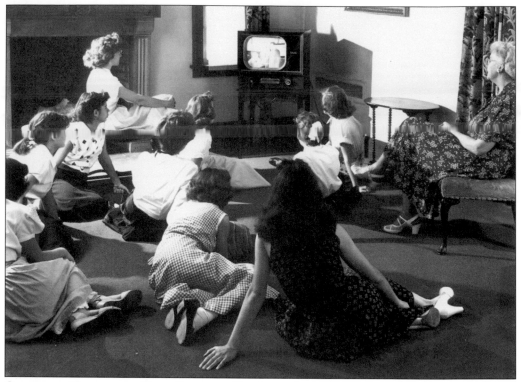

CATHERINE HORSTMANN HOME INTERIOR. Residents also had time to relax and watch television although they were formally dressed by today's standards. The home's emphasis was on teaching the young women appropriate skills such as cooking and housekeeping. (Cleveland Catholic Diocesan Archives.)

CATHERINE HORSTMANN HOME BACKYARD. Residents also learned how to cut the grass and maintain the backyard. In 1970, the institution changed its mission, providing transitional housing for educable mentally retarded women. The home sold the property in 2008 to the Help Foundation. (Cleveland Catholic Diocesan Archives.)

URSULINE COLLEGE STUDENTS, 1962. Poised and posed at the Carlton Road and Overlook Road intersection, these young women illustrate the Catholic—and female—presence on the Overlook in the 1960s. The former Cuddy home, now Merici Hall, is in the background. The Ursulines had begun to buy property at Fairmount Boulevard and Lander Road in 1927 and purchased more land in 1949, anticipating rising enrollment. A convent for the sisters had already been built when this photograph was taken. In 1966, the college left the Overlook and established itself on the new campus in Pepper Pike. (Ursuline College Archives.)

URSULINE COLLEGE, 1926–1966. This poignant portrait of the Overlook in winter may have been the college's nostalgic Christmas card as it prepared to leave its home of 40 years. (Those are probably the steps to Overlook House.) The move to Pepper Pike heralded a new era for Ursuline College, as it moved from mansions that were elegant, but designed for residential use, into new buildings designed specifically for academic purposes. In 2009, those buildings numbered 12. Nine percent of its student body of 1,400 was men. The college offered 23 undergraduate and 9 graduate programs. (Ursuline College Archives.)

APARTMENT AT 2235 OVERLOOK. The controversy over the fate of the Eells mansion was resolved when Cleveland Heights officials rezoned the property for multifamily use, and it became the site of this handsome apartment building, the first on the Overlook when it opened in 1951. (Cleveland State University Special Collections.)

O. F. GORDON/CHANDLER CARRIAGE HOUSE, 1958. This is the largest of the cluster of carriage houses built behind the founding families' mansions and designed by the same distinguished architects—in this case, probably Granger and Meade. (See page 32.) Like the other carriage houses, this had become a separate property from the original mansions. (Cuyahoga County Archives.)

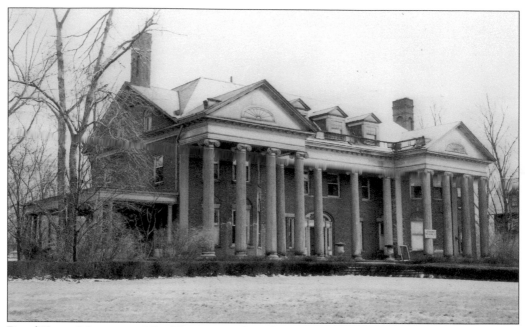

RICE/WHITE MANSION, 1950. The sign on the pillar says "Broadway Wrecking," indicating that the home will soon be demolished. Its neighbor, the Palmer mansion, was already gone. The Overlook's second apartment building, Waldorf Towers, would be built on these two properties. (Cleveland State University Special Collections.)

WALDORF TOWERS, 2300 OVERLOOK. The first high-rise apartment in Cleveland Heights opened in 1961. Other Overlook homes had already become institutional facilities or multifamily dwellings. Waldorf Towers occupies 6 acres, formerly the site of the Rice/White and Palmer homes and gardens. (Author's collection.)

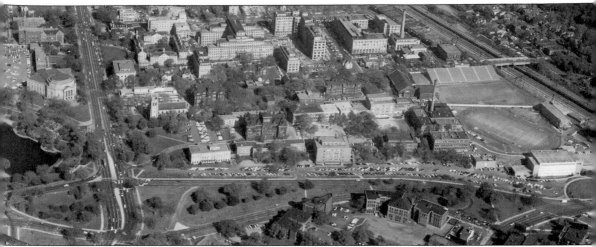

CASE INSTITUTE OF TECHNOLOGY, C. 1958–1960. Case School of Applied Science had become Case Institute of Technology in 1947. Its student body had grown mightily, thanks in part to GIs returning to school. In pursuit of much-needed dormitory space, Case began in 1959 to buy properties east of Murray Hill Road, up the hill to Carlton Road and the Overlook. The need for space was exacerbated when Case and Western Reserve University federated in 1967. The photograph illustrates the two campuses, cramped between Euclid Avenue on the west, University Hospitals on the north, railroad tracks on the east, and East Boulevard on the south. (Some Western Reserve University buildings were located west of Euclid Avenue.) Talk of combining the two institutions dated back to the 1920s and came to fruition 40 years later, partly due to the desire to compete successfully with the new Cleveland State University. Alumni and faculty of both institutions were less enthusiastic about the federation than were Case president T. Keith Glennan and Western Reserve University president John S. Millis. (Case Western Reserve University Archives.)

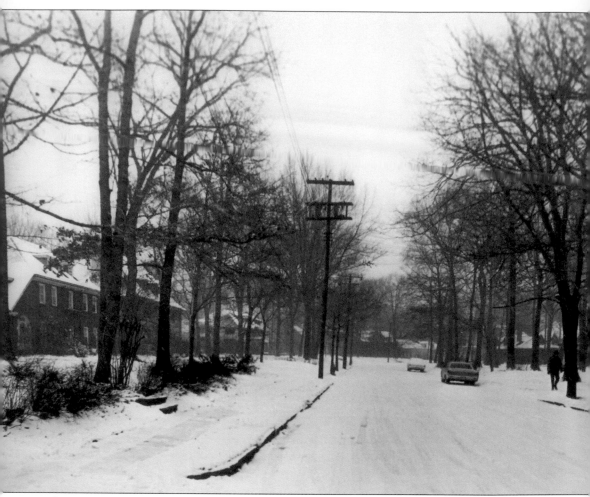

CARLTON ROAD, 1966. The view east on Carlton shows the private homes that remained after Case had begun demolishing those at the western end of the cul-de-sac in 1963. Remaining residents protested what they called a "high pressured, ill-mannered campaign" to buy their properties for residence halls and fraternity houses. Case, however, saw Carlton Road—and the Overlook—as a logical route for expansion, especially since Ursuline College had established the precedent for an academic presence in the residential neighborhood, and as a way of halting the neighborhood's "deterioration," as the Case Board of Trustees tactfully expressed it. The university also began to express an interest in the Ursuline properties in 1961. (Cleveland State University Special Collections.)

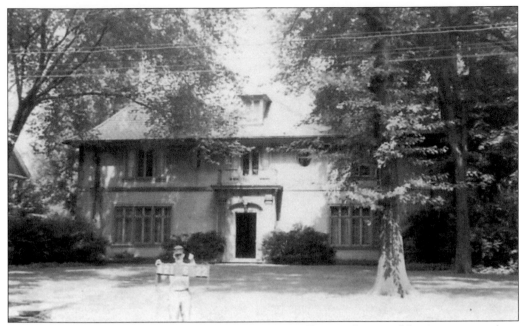

DEMOLISHED HOME, 11925 CARLTON ROAD. Case initially rented some of the properties; others were left vacant. Although the university considered using the homes for graduate or other housing, almost all were demolished by 1969. This photograph was taken in 1958 by Cuyahoga County. (Cuyahoga County Archives.)

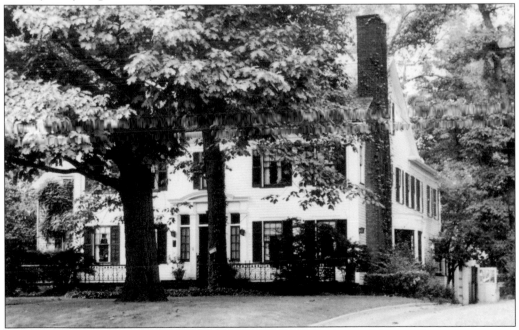

JAMISON HOME, 11957 CARLTON ROAD. The owner of this home, Marjorie Jamison, was one of the few holdouts who refused to sell to the university, and the university did not acquire the property until 1999. It was demolished soon afterwards. Two Carlton Road homes remain in 2009, although both are now the properties of Case Western Reserve University. (Case Western Reserve University Archives.)

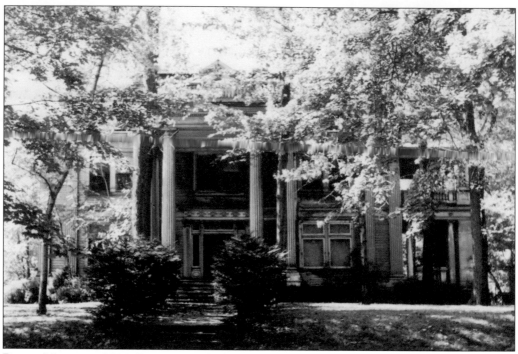

DODGE MANSION, 2224 OVERLOOK. The home became doctors' offices in the 1940s and appears rather deteriorated in this undated photograph. It was purchased by Northern Ohio Trustees, owners of Overlook House, traded to Case Western Reserve University for the Norton home on Overlook, and then demolished by the university in 1968. (Case Western Reserve University Archives.)

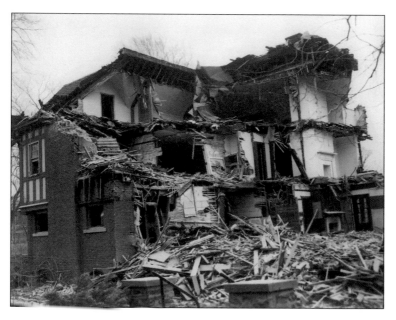

DEMOLITION OF BEAUMONT HALL, 1969. Case Western Reserve University apparently did not record the demolition of the Carlton and Overlook homes, but Ursuline College took this photograph of the razing of its former administration and academic building, originally the home of Hermon Kelley. (See page 33.) (Ursuline College Archives.)

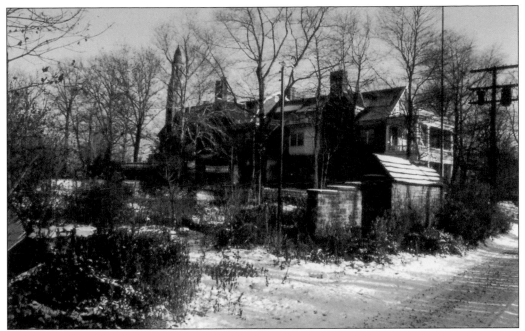

OVERLOOK HOUSE GARDEN WALL. The campanile of the First Church of Christ, Scientist, Cleveland, appears behind Overlook House, emphasizing the close connection between the two institutions and the significant Christian Science presence on the boulevard. The wall has survived. (See page 113.) (Jean Breitzmann.)

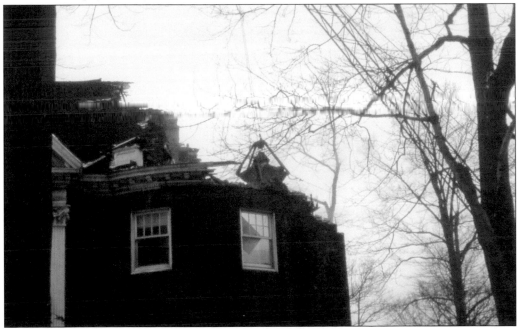

DEMOLITION OF OVERLOOK HOUSE, 1968. Two decades after its purchase by the Northern Ohio Trustees—and more than seven decades after its completion—the Herrick/Crowell mansion had become too small and too outdated for a nursing facility, and it was razed in 1968. Patients were moved to a more contemporary building on the property. (See page 107.) (Jean Breitzmann.)

New Building Progresses

Although additional gifts are needed to complete the Overlook Building Fund, construction work on the new nurses' residence and rest and study wing is progressing daily.

The completion date for the new facility has been set for November, 1973. The main building will contain twelve completely furnished apartments for nurses' quarters. Six rest and study suites will form a separate wing.

These facilities will match the architecture of Overlook House, but will be separated from the sanatorium.

Now that the building is underway, gifts to the Overlook Building Fund will be welcome. For more details about this project, or for the receipt of gifts of cash or securities, please write to:

Mr. Malcolm Neale
Chairman
Overlook Building Fund

Overlook House
2187 Overlook Road • Cleveland, Ohio 44106

Only the walls of Kulas House remain as the wrecker works to complete the demolition.

Concrete walls begin to rise as the new nurses' residence and rest and study wing takes form.

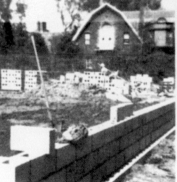

The building site is cleared for the footings and utilities.

DEMOLITION OF RUST/NORTON HOME, 1972. After it was acquired from Case Western Reserve University, the home was used as apartments for the nurses at Overlook House. This photograph of its razing appeared in the June 1973 *Overlook Messenger*, the newsletter of the nursing facility. A new apartment was finished in 1974. (See page 107.) This was the last of the first families' mansions to be demolished. (Janet Kopp.)

Six

CHANGE AND CONTINUITY
1975–2009

The Overlook has continued to change. The residence halls and fraternity houses of Case Western Reserve University's South Residential campus have supplanted Carlton Road homes. Most of the gracious lawns of the Overlook are gone, but the university maintains a small park and tennis courts where the Cuddy, Kelly, Dodge, and Sherwin mansions used to be. The First Church of Christ, Scientist, Cleveland, and the Christian Science nursing facility, Overlook House, have left the neighborhood; so have the Catherine Horstmann Home and the United Cerebral Palsy Foundation. Their old buildings have new owners. Just to the east, there is new housing on Kenilworth Mews and Euclid Heights Boulevard, near the site of William Lowe Rice's magnificent estate—and his murder.

The glory days of the Overlook—and perhaps those of Cleveland and Cleveland Heights, with declining populations and diminishing economic resources—may be over. But on the Overlook there are remains of the day when it briefly became home to some of "the wealthiest Clevelanders." Three of the original mansions have survived. The walls that defined the Eells, Herrick, and Kelley properties still stand. The first families' carriage houses on Herrick Mews have become elegant residences listed on the National Register of Historic Places. In 2002, Nottingham Spirk and Design purchased and retrofitted the First Church of Christ, Scientist, Cleveland, maintaining the architectural splendor of the boulevard. Its campanile can be seen from Cleveland and Cleveland Heights, marking the spot where Patrick Calhoun's ambitions briefly took shape.

VIEW FROM CEDAR GLEN PARKWAY. The entrance to the Overlook is marked today not by the Kelley and Cuddy mansions, but by this distinctive sign and logo of Case Western Reserve University, whose tennis courts, park, residence halls, commons, and fraternities have made it the dominant presence in the neighborhood. Most of the university campus lies down the hill to the west in University Circle on properties purchased initially by Amasa Stone and other benefactors. The university enrolls almost 10,000 students in its undergraduate and graduate schools of medicine, law, management, social work, dental medicine, nursing, and graduate studies on its University Circle campus, surrounded by a dozen other cultural institutions and University Hospitals. (James W. Garrett IV.)

CARLTON ROAD KIOSK. On this upper part of the South Residential Village, at the very edge of the bluff, where the distinguished suburban homes of Carlton Road once stood, is this kiosk and sign that reinforce the university presence. Surrounding this central space are Glaser, Michelson, and Kusch residence halls, several fraternity houses, and Fribley and Carlton Commons. (James W. Garrett IV.)

STAIRWAY FROM THE "TOP OF THE HILL." The steep, winding stairway connects the "Top of the Hill" Carlton Road campus with the Murray Hill ("Bottom of the Hill") dormitories just below and the sprawling main campus, which is still centered on Euclid Avenue. (James W. Garrett IV.)

PHI SIGMA PI FRATERNITY HOUSE. This is the former home of Lockwood Thompson at 11901 Carlton Road. He was a member of the Cleveland Public Library Board. Thompson was one of the few holdouts on Carlton when the university first approached homeowners on the street. The university did not acquire the property until 1993, after Thompson's death. (James W. Garrett IV.)

GLASER HALL. Bicycles at the entrance of this residential hall indicate that energetic students live within. The "Top of the Hill" high-rise apartments house only second-year students. The contemporary style of this utilitarian brick dormitory is used throughout the South Residential Village, creating a coherent cluster of attractive buildings in marked contrast with the two remaining Carlton homes and the eclectic main campus to the west. (James W. Garrett IV.)

104

OVERLOOK PARK. This small park on the former site of the Dodge and Sherwin mansions and the Ursuline dormitories preserves green space on the Overlook. The campanile of Nottingham Spirk and Design, formerly the First Church of Christ, Scientist, Cleveland, overlooks the park. (James W. Garrett IV.)

GRID 14. This handsome sculpture by Jon Fordyce is part of the John and Mildred Putnam Collection. It stands to the north of the university tennis courts on the former site of the Ursuline College buildings. Outdoor public art adds visual interest to the South Residential Village and the boulevard. (Author's collection.)

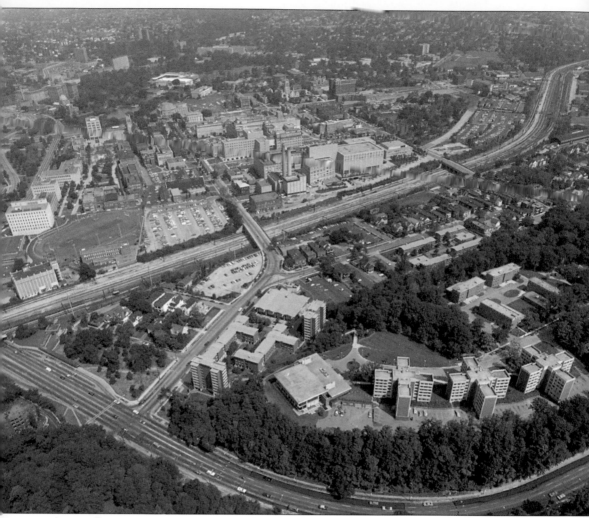

Aerial Photograph, South Residential Village. Cedar Road, in the immediate foreground, curves down Cedar Glen to University Circle and the city of Cleveland. Buffered by the stand of trees, the Carlton Road "Top of the Hill" high-rise residence halls stand just above Cedar Glen; the "Bottom of the Hill" Murray Hill dormitories are to their left. The natural bluff that divides the two is not apparent. Across the railroad tracks are the many buildings of University Hospitals and then farther to the west is the main campus of Case Western Reserve University. The photograph captures the urban feel of the expanding university, dramatically different from the two small colleges of the 1880s. (Case Western Reserve University Archives.)

OVERLOOK HOUSE. This contemporary building, completed in 1969, replaced the Herrick/Crowell mansion that the Overlook House had occupied for almost 20 years. When Overlook House closed in 2009, the building was purchased by the A. M. McGregor Group, which will operate its second long-term care nursing home there. (Author's collection)

VIEW OF 2215 OVERLOOK. The apartment for the nurses at Overlook House was completed in 1974 on the site of the Rust/Norton home. When the Christian Science nursing facility closed, this building was purchased by a local realty company with plans to rent the apartments to students. (Author's collection.)

BROWNSTONES AT DERBYSHIRE. The first owner of this handsome Gothic building, the congregation of the First English Lutheran Church (see page 79), disbanded in 2002 and sold it to a developer, who transformed the church into condominiums. These provide elegant new housing for the neighborhood. (James W. Garrett IV.)

KENILWORTH MEWS. The Overlook's newest neighbors are cluster homes built directly to the east of Herrick Mews on or near the former site of William Lowe Rice's gardens. They are designed in the arts and crafts style, to be compatible with the homes on Herrick Mews. (Charles Miller.)

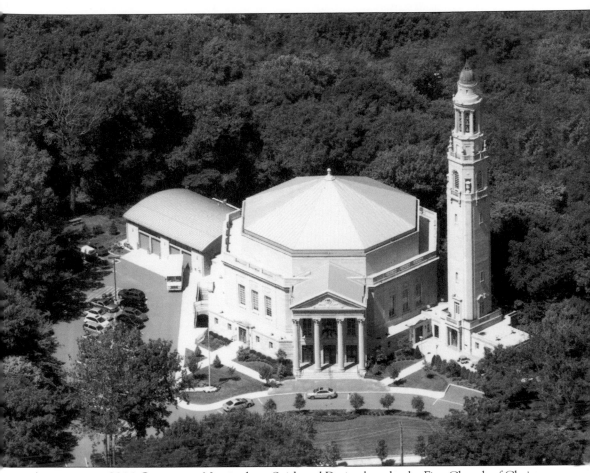

ADDITIONS AT 2200 OVERLOOK. Nottingham Spirk and Design bought the First Church of Christ, Scientist, Cleveland, in 2003 and left the exterior essentially unchanged except for the addition to the left and the new name over the entrance. The building became the firm's Innovation Center. The photograph illustrates the size of the original site, originally the Howell Hinds property. The park and buildings of Case Western Reserve University are hidden behind the trees, probably denser and taller than when the Overlook families built their homes. The firm's adaptive reuse of the historic church, designed by Walker and Weeks, has won several architectural awards. (Nottingham Spirk and Design.)

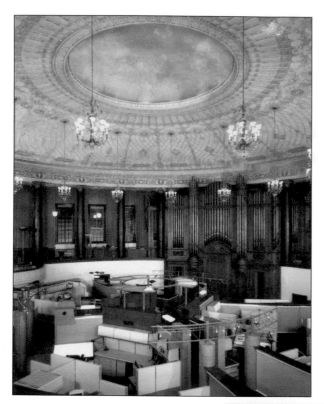

INNOVATION CENTER DESIGN STUDIO. The firm has transformed the church's auditorium into separate work spaces, preserving the original woodwork, organ, light fixtures, and ceiling with its oculus. The firm designs consumer, industrial, and medical products. (Nottingham Spirk and Design.)

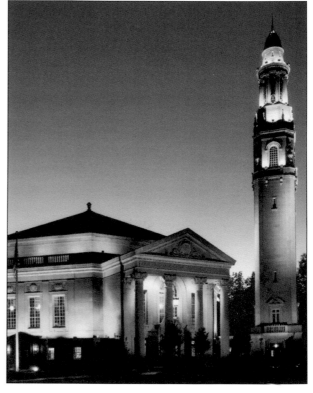

INNOVATION CENTER CAMPANILE. The semidetached bell tower, lighted or not, dominates the Overlook's skyline. Standing at the very top of the bluff, overlooking the city and university to the west, the campanile is visible for miles. Like the Innovation Center, it sustains the grandeur of the Overlook. (Nottingham Spirk and Design.)

GRANGER'S 2141 OVERLOOK. This, the first home on the Overlook, was designed by Alfred Hoyt Granger for himself. The home was owned by the family of Melvin B. Johnson, until 1952, when it became a nursery school for the United Cerebral Palsy Foundation. When the foundation sold it, the Tudor Revival home became apartments and offices. (Author's collection.)

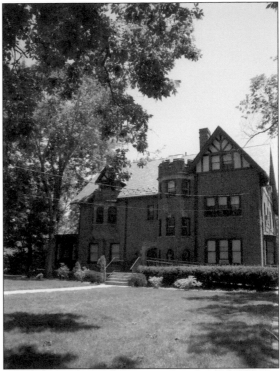

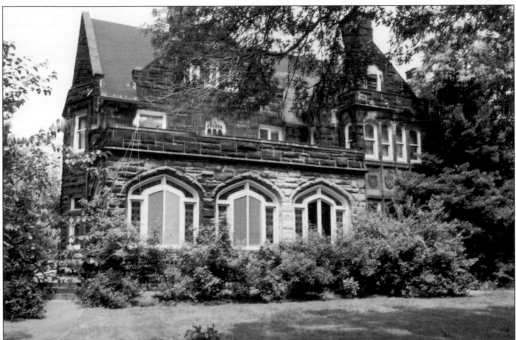

GRANGER'S 2380 OVERLOOK. Built for John Hartness Brown, the handsome Richardsonian Romanesque home, also designed by Alfred Hoyt Granger, is one of the three original mansions that have survived and the only one that is still a single-family residence. Its rough stone exterior has darkened with age but maintains the home's original dignity. (Author's collection.)

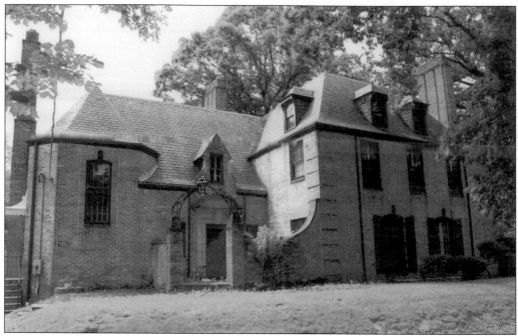

REMODELED 2155 OVERLOOK. On the site of the home built for Dr. O. F. Gordon and occupied by George N. Chandler and his family, this home was very possibly remodeled or rebuilt by their son George R. Chandler, who sold it to the Catharine Horstmann home in 1951. It was recently purchased by the Help Foundation, which provides services to adults and children with mental retardation and developmental disabilities. (Charles Miller.)

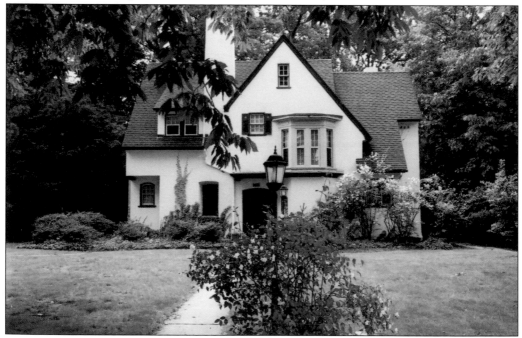

VIEW OF 11930 CARLTON ROAD. The second of the surviving Carlton Road homes, this Tudor Revival home is also now owned by the university. It serves as faculty housing. (James W. Garrett IV.)

BEAUMONT HALL WALL. This is the remnant of the wall that divided the Kelly property and then Ursuline College's Beaumont Hall from the Carlton Road homes to the west. The entire wall is pictured on page 78. (Author's collection.)

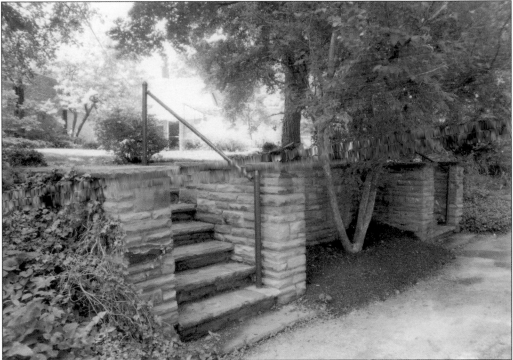

HERRICK GARDEN STEPS. These led from the Herrick mansion to his gardens on the other side of what was originally Kenilworth Road and is now Herrick Mews. Kenilworth may have been vacated to facilitate Herrick's access to the gardens. Overlook House is in the background. (Author's collection.)

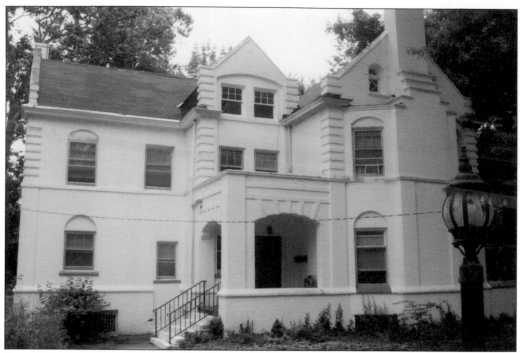

BUILDING AT 2225 OVERLOOK. The sharply pitched gables and ornamental brickwork of this building, once the servants' quarters of the Eells mansion, suggest the Tudor elements of the original mansion. (See page 45.) This is one of three buildings on the property. It is now an apartment building. (James W. Garrett IV.)

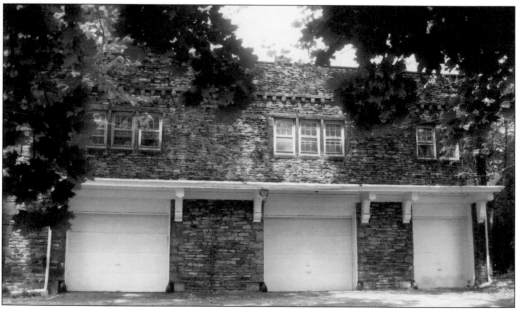

HOME ON 2361 EUCLID HEIGHTS BOULEVARD. The handsome building, once a garage, is now a two-family home, built of the same stone as the wall that surrounded the Eells' property. The decorative stonework above the windows is reminiscent of the original mansion's elegance. (James W. Garrett IV.)

ALMOST UNCHANGED, 2348 OVERLOOK. One of the three original mansions that has survived, this was the home of W. B. D. Alexander and then D. Edward Dangler. In 1951, it became the College Club of Cleveland. The exterior is substantially unchanged except for the enclosure of a side porch and the addition of a ramp to make the club handicapped-accessible. (College Club of Cleveland.)

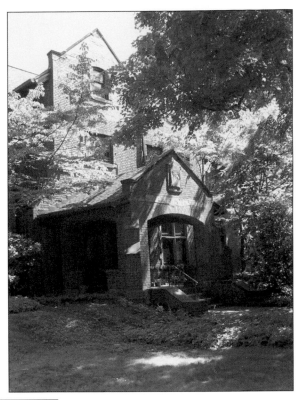

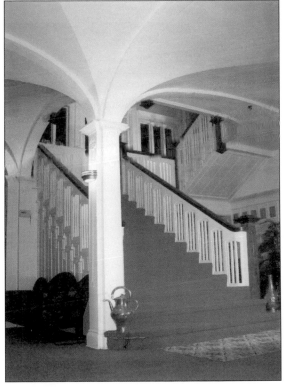

COLLEGE CLUB OF CLEVELAND INTERIOR. The club has retained the arts and crafts decorative details of the original interior design as well as its spacious center hall entrance. The home is a Cleveland Heights landmark. (College Club of Cleveland.)

COLLEGE CLUB OF CLEVELAND INTERIOR DETAIL. Originally for women college graduates, the club now admits men and hosts a variety of social and educational activities. As this photograph illustrates, the club has maintained its literary and intellectual focus as well as the home's interior design. (College Club of Cleveland.)

2350 OVERLOOK. The club's annex was formerly the Alexander carriage house. Like the other Overlook carriage houses, this has been adapted for modern use. It houses a studio for art classes as well as a separate apartment. (College Club of Cleveland.)

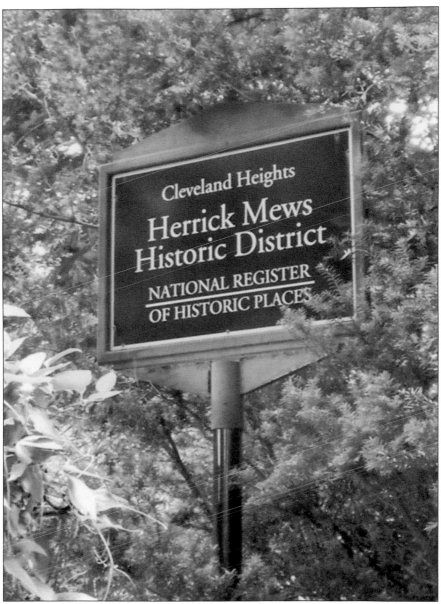

HERRICK MEWS HISTORIC DISTRICT. This cluster of carriage houses, built by the founding families of the Overlook for their servants, horses, and cars, is located on what was originally Kenilworth Road as it intersected with the Overlook, just to the south of Myron T. Herrick's home. In 1974, in his nomination of the homes to the National Register of Historic Places, architectural historian Eric Johannesen described the carriage houses as a "group unique in greater Cleveland . . . clustered together around a private alley and forming the equivalent of a British mews. [The homes] clearly embody one aspect of the style of living among the wealthy class at the turn of the twentieth century." In 1975, Cleveland Heights renamed the then-private roadway Herrick Mews in honor of Myron T. Herrick. Herrick Mews became a Cleveland Heights landmark in 1976. These historic designations probably helped residents block an expansion planned by Waldorf Towers in 1998 that would have altered the historic character of the street. There was less opposition to building the upscale town houses on the adjoining Kenilworth Mews. (Author's collection.)

HERRICK MEWS NO. 1. This Georgian Revival home, the southernmost and most stylish of the houses, was designed for Herrick by Alfred Hoyt Granger and Frank Meade and was presumably completed in 1897, when Herrick's mansion was finished. The next owner of the home, Benedict Crowell, reportedly filled in Herrick's sunken gardens. (Charles Miller.)

HERRICK MEWS NO. 1 GARDEN. Herrick Mews No. 1 is separated from the other homes by this charming garden. This and other gardens offer seclusion and privacy for Mews residents, whose properties back onto the high-rise building, formerly the Margaret Wagner House and now Concordia Care, on busy Euclid Heights Boulevard. (Author's collection.)

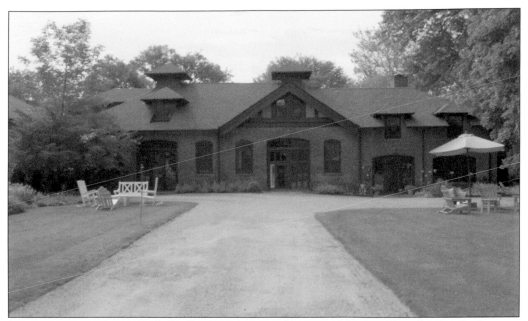

HERRICK MEWS NO. 2. Built for Dr. O. F. Gordon, but owned by the Chandler family for most of its history, this sweeping, horizontal residence boasts interesting architectural details such as multiple protruding gables. The interiors of all the Mews homes have been adapted for residential use. (Charles Miller.)

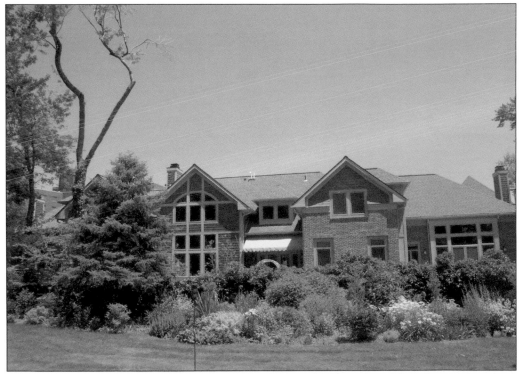

HERRICK MEWS NO. 2 GARDEN. This home is also distinguished by its broad front lawn and gardens. The back of a new Kenilworth Mews home appears over the garden wall. (Author's collection.)

HERRICK MEWS POCKET GARDEN. Herrick Mews No. 3, 4, and 5, built for Howell Hinds, Homer H. Johnson, and Melvin B. Johnson, respectively, face each other across a driveway. Each has a small garden. (Charles Miller.)

HERRICK MEWS No. 5. This spacious building is now two separate apartments. Although the carriage houses were designed in different styles, all are brick and create a coherent cluster of homes. Ironically, all have outlasted the mansions—except for 2141 Overlook Road—for which they were built. Herrick Mews remains the best evidence of Patrick Calhoun's ambitions. (Charles Miller.)

Seven

EPILOGUE

This story of the Overlook ends where it began: at Lake View Cemetery, a stone's throw from the elegant residential boulevard that Patrick Calhoun imagined almost 120 years ago. Calhoun died in 1943, having recouped his fortune and his reputation elsewhere, and he is buried in the family cemetery in Clemson, South Carolina. But most of the Overlook's founding families remain at Lake View Cemetery, close to the Garfield Monument with its splendid view of Lake Erie that inspired their temporal homes on the boulevard. The solemn headstones of their family plots, neighbors in death as in life, recall their shared part in a grand but ephemeral design.

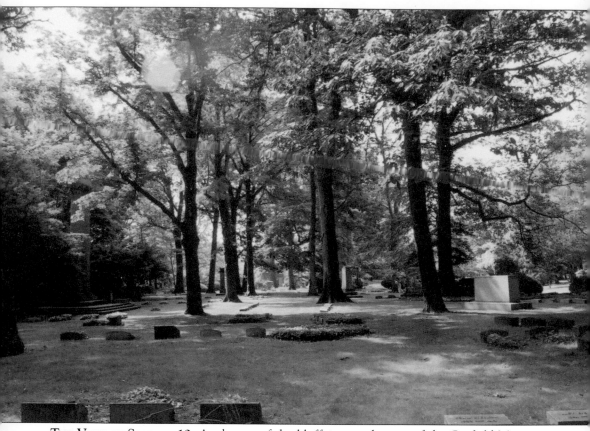

THE VIEW OF SECTION 10. At the top of the bluff, just to the east of the Garfield Monument, Section 10 is the permanent home of many prominent Cleveland families, including those of John D. Rockefeller, John L. Severance, Amasa Stone, and Charles Brush. Several Overlook families have joined them there. The green lawns and tall trees are reminiscent of the Overlook. E. W. Bowditch designed the curving roadways of both. Neighbors Loftus Cuddy, Hermon Kelley, and William Lowe Rice are buried here. (James W. Garrett IV.)

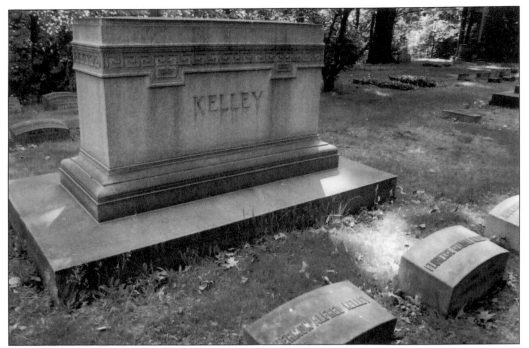

KELLEY HEADSTONE. Attorney Hermon Kelley was one of the first of the founding families. His mansion became Beaumont Hall of Ursuline College, the first institution on the Overlook. Kelley is buried here with his wife and children. (James W. Garrett IV.)

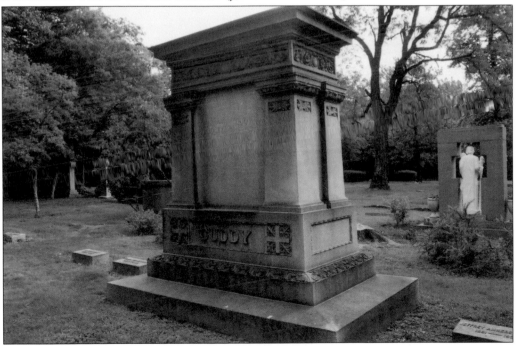

CUDDY HEADSTONE. Kelley's next-door neighbor Loftus Cuddy is buried just to the north of the Kelley plot. His imposing monument with its dignified ornamentation is not unlike his mansion, which became Merici Hall, the site of some of Ursuline College's solemn ceremonies. (James W. Garrett IV.)

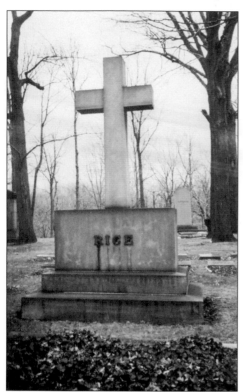

RICE HEADSTONE. The mystery of William Lowe Rice's murder in 1910 in his own Overlook backyard remains unsolved. The austere headstone of this entrepreneur and moving spirit behind the Overlook bears nothing but the family name. His wife and two daughters are also buried here. (Author's collection)

HERRICK HEADSTONE. The best known of the Overlook residents, Myron T. Herrick, has this unassuming headstone in Section 9; the flag commemorates his service to his country as ambassador to France. The secluded mews off the Overlook that bear his name more visibly sustains his local fame. Overlook neighbor Howard P. Eells and his family are buried close by. (James W. Garrett IV.)

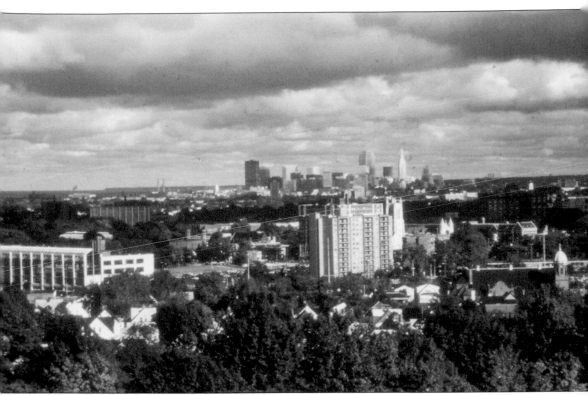

THE VIEW FROM THE GARFIELD MONUMENT. The view is remarkably different from the one that reportedly inspired Calhoun to create Euclid Heights. The city's skyline is punctuated with skyscrapers, not smokestacks. Closer to the monument are the high-rise buildings of Case Western Reserve University, the site, in 1890, of the much more modest campuses of Case School of Applied Social Science and Western Reserve College; closer still, the homes of Little Italy and Holy Rosary Church, still unbuilt when Calhoun first visited. In the farthest distance, however, appears, as Calhoun first saw it in 1890, "the most beautiful reach of Lake Erie." (Laura Dempsey.)

Bibliography

Barrow, William C. "The Euclid Heights Allotment: A Palimpsest of the Nineteenth-Century Search for Real Estate Value in Cleveland's East End." Master's thesis, Cleveland State University, 1997.

Bellamy, John Stark. *They Died Crawling and Other Tales of Cleveland Woe*. Cleveland: Gray and Company, 1995.

Cigliano, Jan. *Showplace of America: Cleveland's Euclid Avenue, 1850–1910*. Kent, OH: Kent State University Press, 1991.

Cigliano, Jan, and Sarah Bradford Landau, eds. *The Grand American Avenue, 1850–1920*. San Francisco: Pomegranate Artbooks, 1994.

Cramer, C. H. *Case Western Reserve: A History of the University, 1826–1976*. Boston: Little, Brown, and Company, 1976.

Gelbridge, Anna Margaret. "Ursuline College, Leader in Educating Women." In *Cradle of Conscience: Ohio's Independent Colleges and Universities*, edited by John William Oliver Jr., James A. Hodges, and James H. O'Donnel. Kent, Ohio: Kent State University Press, 2003.

Hamley, Kara. "Cleveland's Park Allotment: Euclid Heights, Cleveland Heights, Ohio and Its Developer, Ernest W. Bowditch." Master's thesis. Cornell University, 1996.

Johannesen, Eric. *A Cleveland Legacy: The Architecture of Walker and Weeks*. Kent, OH: Kent State University Press, 1999.

Jones, Suzanne Ringler. *In Our Day: Cleveland Heights—Its People, Its Places, Its Past*. Cleveland Heights, OH: Heights Community Congress, 1977.

Morton, Marian J. *Cleveland Heights: The Making of an Urban Suburb*. Charleston, SC: Arcadia Publishing, 2003.

Rose, William Ganson. *Cleveland: The Making of a City*. Cleveland: World Publishing Company, 1950.

Van Tassel, David V., and John G. Grabowski. *Encyclopedia of Cleveland History*. Bloomington, IN: Indiana University Press, 1987.

Wick, Mildred Calhoun. *Living With Love*. Newport, Delaware: Serendipity Press, 1986.

Women's Civic Club of Cleveland Heights. Manuscript 3641, Western Reserve Historical Society, Cleveland.

INDEX

Discover Thousands of Local History Books Featuring Millions of Vintage Images

Arcadia Publishing, the leading local history publisher in the United States, is committed to making history accessible and meaningful through publishing books that celebrate and preserve the heritage of America's people and places.

Find more books like this at
www.arcadiapublishing.com

Search for your hometown history, your old stomping grounds, and even your favorite sports team.

Consistent with our mission to preserve history on a local level, this book was printed in South Carolina on American-made paper and manufactured entirely in the United States. Products carrying the accredited Forest Stewardship Council (FSC) label are printed on 100 percent FSC-certified paper.

MADE IN THE USA